SOMERSET
THROUGH TIME
Steve Wallis

BRADWELL
BOOKS

Acknowledgements

I would like to thank Rose Barnes, Deborah Edwards, Andy Foster and Phil Sterling for their assistance in the writing and photography of this book.

First published in 2012 by
Amberley Publishing for Bradwell Books

Amberley Publishing
The Hill, Stroud
Gloucestershire, GL5 4EP
www.amberley-books.com

Copyright © Steve Wallis, 2012

The right of Steve Wallis to be identified as the
Author of this work has been asserted in accordance
with the Copyrights, Designs and Patents Act 1988.

ISBN 978 1 4456 0720 7

British Library Cataloguing in Publication Data.
A catalogue record for this book is available from
the British Library.

Typeset in 9.5pt on 12pt Celeste.
Typesetting by Amberley Publishing.
Printed in the UK.

Introduction

After deciding to write a *Through Time* volume on Somerset, the first thing I had to consider was what area to use as my subject matter. The answer to this is not as obvious as it may seem, for there have been various boundary and administrative changes over the past few decades. I settled on the 'ceremonial county', the area for which the Lord Lieutenant is responsible. This has the same boundary that Somerset had before the major reorganisation in 1974. It includes today's North Somerset as well as Bath and North-East Somerset, but not Bristol.

Like others in this series, this book compares old and new photographs of selected locations to show how things have or perhaps have not changed. Indeed, in some cases, you may have to look closely to see differences between the photographs.

I have tried to match the viewpoints of my 'modern' photographs as closely as I can to those used by the old photographers. In some cases this has been impractical because the view from that location is now obscured by vegetation, new housing, or the like, and I have had to find the closest reasonable place. A good example is the view of Bath taken from Beechen Cliff, where there has been some very healthy growth of the trees over the past century, so that I had to find a spot some distance from the original viewpoint to get a look across the city.

My aim of taking photographs from as close as possible to the same spot as the original sometimes has had a 'warts and all' effect. My photographs sometimes show parked cars, street furniture, overhead lines and so on, which while not exactly photogenic are an essential part of modern life.

The dates given are estimates of when the older pictures were taken.

Inland Towns and Cities

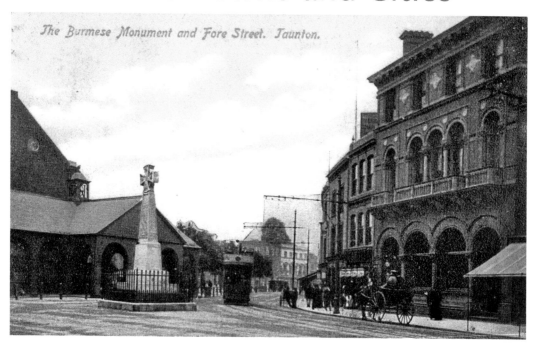

The Burmese Monument and Fore Street. Taunton.

Taunton, The Burmese Monument, *c. 1900*

We will begin with a tour of some of Somerset's inland towns and cities, looking first at the county town, then going west before going around clockwise. The old picture here looks from East Street around Fore Street, with the Burmese Monument on the left in front of the Market House. The Monument commemorates men of the Somersetshire Light Infantry killed in Burma between 1885 and 1887. The Monument was moved in 1996 to the location beyond the Market House shown in my picture.

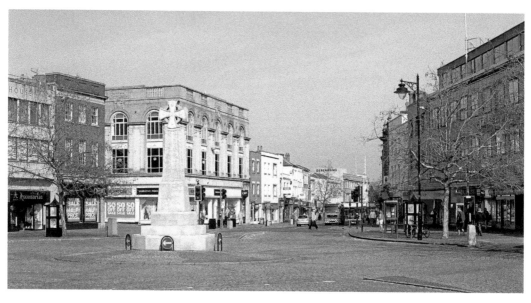

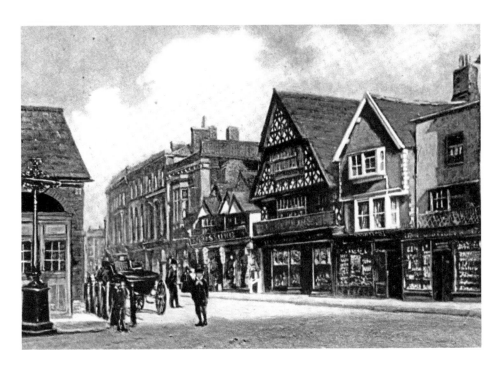

Taunton, Fore Street, *c.* 1900

Fore Street is the triangular area around the Market House, and here we have moved over to the south-west corner. Part of the Market House is on the left – the present building dates from the early 1770s, but it was altered in the 1930s and you can see differences between the two photographs. The buildings on the right include some of Taunton's oldest. The central timber-framed one was formerly called the Tudor Tavern, although some of the inside actually dates to the fourteenth century.

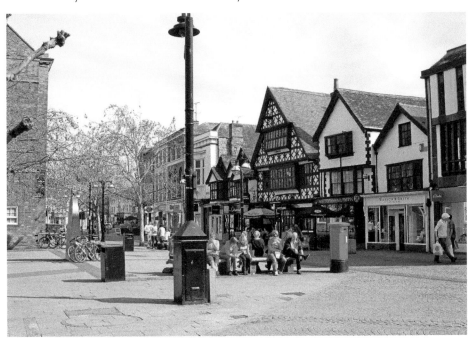

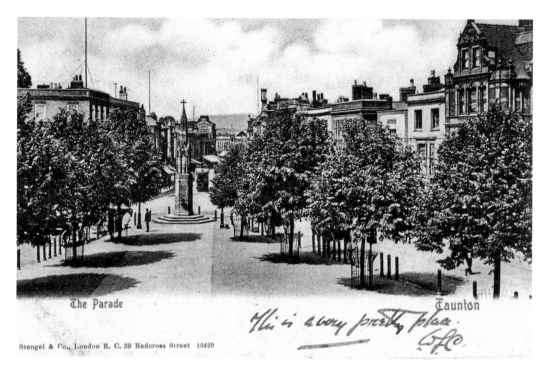

Stengel & Co., London E. C. 39 Redcross Street 16429

Taunton, The Parade, c. 1905

Now we look north across The Parade towards North Street. The old photograph must have been taken from upstairs in the Market House. The prominent structure is the Market Cross, erected in 1867 on the site of a medieval predecessor. My picture was taken from beside the Burmese Monument.

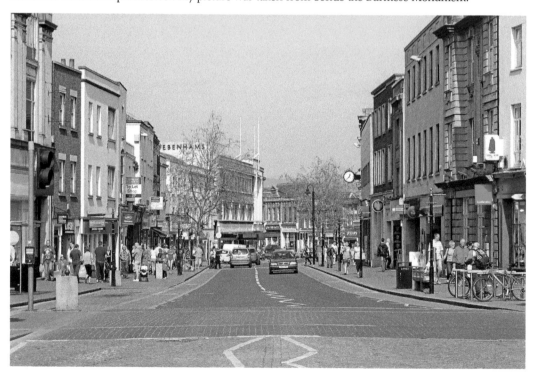

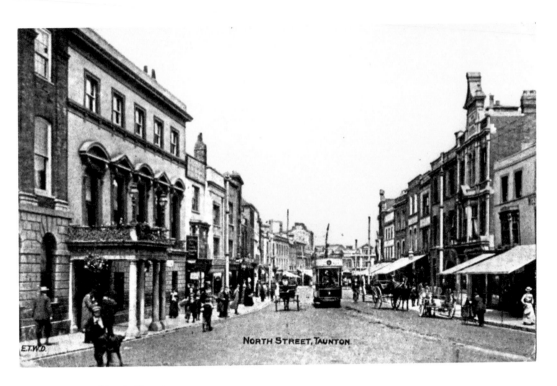

NORTH STREET, TAUNTON.

Taunton, North Street, *c.* 1900

We advance a short way into North Street. The old picture is a good example of a late Victorian or early Edwardian street scene. Compare it with my photograph and you also get a fair idea of how many eighteenth- and nineteenth-century buildings were lost or significantly altered during the twentieth century. Indeed, I found it difficult to work out the exact location from which the old picture was taken.

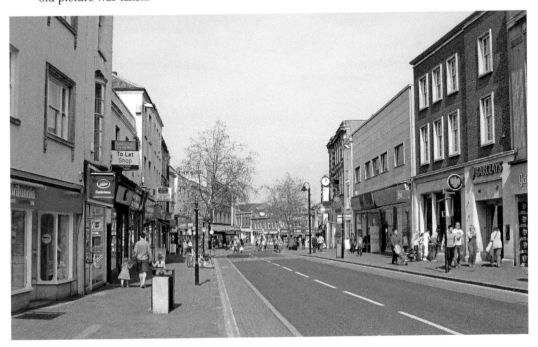

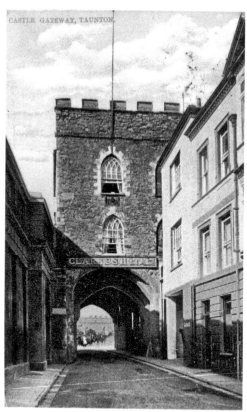

Taunton, Castle Gateway, *c.* 1905
From close by, we turn westward to look
into the alley called Castle Bow. This leads
up to Taunton's twelfth-century castle,
which now houses the Museum of Somerset.
The structure above the alley is one of the
thirteenth-century gatehouses to the castle,
which has been incorporated into the
adjacent Castle Hotel.

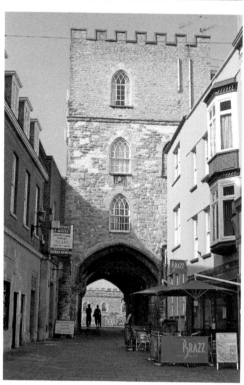

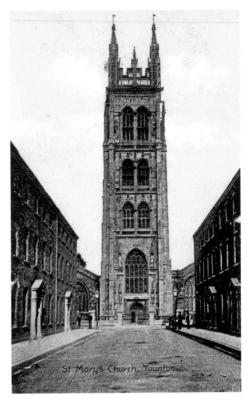

St Mary's Church, Taunton.

Taunton, Hammet Street, *c.* 1905
Then we head back across North Street and go
into Hammet Street for one of the best views
within the town. The street itself is lined with
Georgian buildings of regular design, and at
the end is the fifteenth-century tower of
St Mary Magdalene's church. Remarkably, this
tower was taken down to ground level and
rebuilt completely when the church was being
restored between 1858 and 1862.

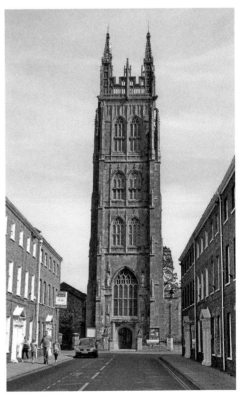

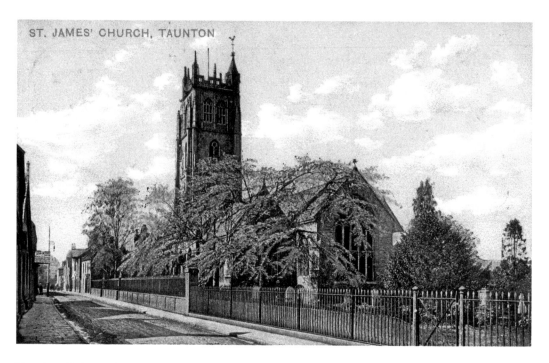

Taunton, St James Street, *c.* 1905

Now around to St James Street to the north. The main focus of the old picture is St James church, another late medieval building whose tower was rebuilt in Victorian times. Around 1500 several almshouses were built in this street – these were demolished in 1897 and one was reconstructed at the Museum of Somerset. Some more recent almshouses, probably built not long after the old picture was taken, are on the right of my shot.

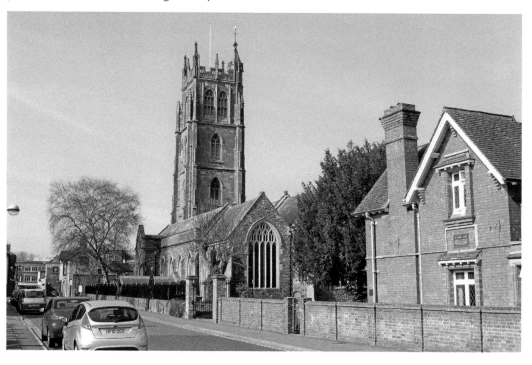

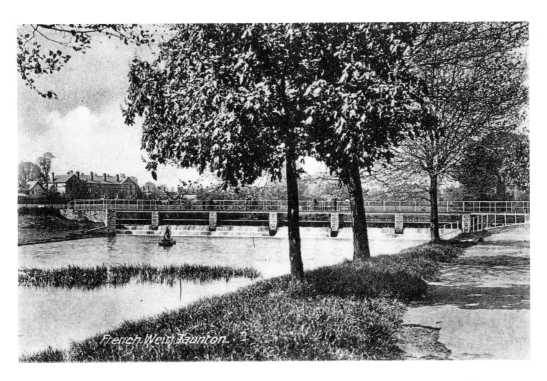

Taunton, French Weir, *c.* 1905

The River Tone flows through the town on the north side of the town centre. I was unable to discover why this weir is called 'French'. It is about a quarter of a mile west of the castle in a little park that bears its name. Today the footbridge above the weir carries the West Deane Way, a long-distance footpath that starts and finishes in Taunton.

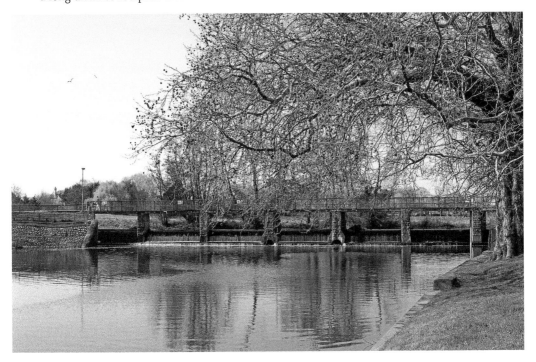

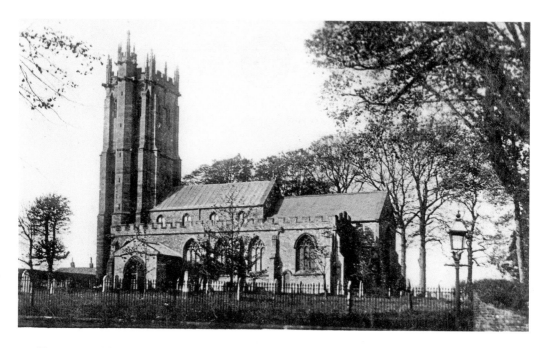

Wellington, Parish Church of St John the Baptist, *c.* 1905

Wellington is some five miles south-west of Taunton. It is overlooked by the Blackdown Hills, on which there is a monument to the victory at Waterloo by the Duke who bears the town's name. The parish church is at the eastern end of the town, and here we see various changes over the past century. The gravestones have been taken up and now line the boundary walls of the churchyard, and housing has appeared in the background.

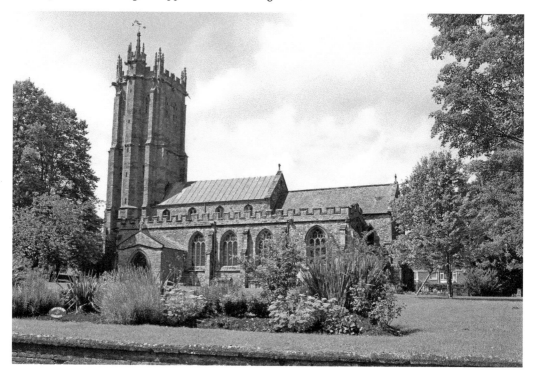

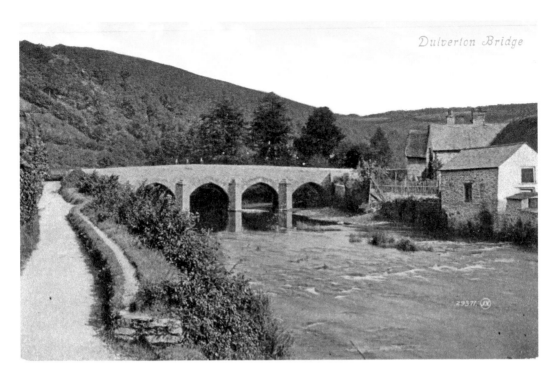

Dulverton, Barle Bridge, *c.* 1905

Dulverton is another twelve miles to the west, as the crow flies at least. It lies beside the River Barle in the southern part of Exmoor, for which it is an administrative centre. The settlement grew up at an important crossing point of that river (part of the name 'Dulverton' means 'ford' in old English), and in the Middle Ages this impressive five-span bridge was built.

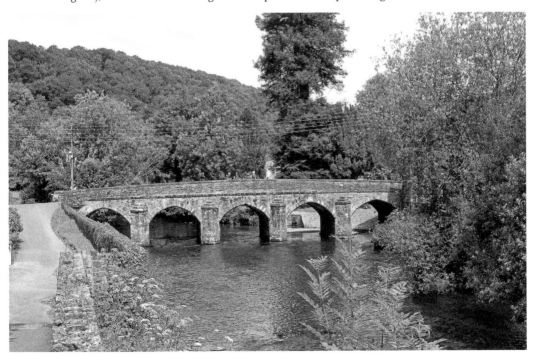

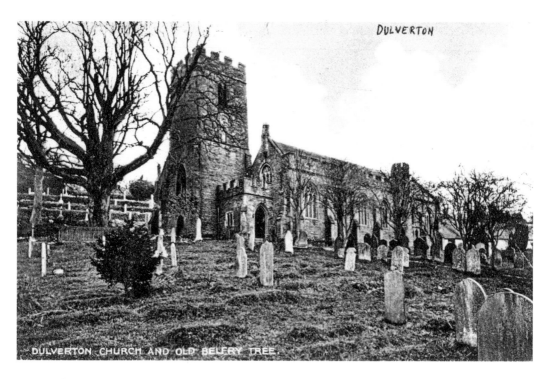

DULVERTON CHURCH AND OLD BELFRY TREE.

Dulverton, All Saints Church and Belfry Tree, *c.* 1925

Across the town centre, where the land starts to rise up out of the valley bottom, we find the parish church with its thirteenth-century tower. The old photograph, taken from Church Walk, shows what was once a local landmark, a giant sycamore that was much bigger than the tower. Today there is just a mound left, while the view from Church Walk is blocked by some rather attractive yew trees.

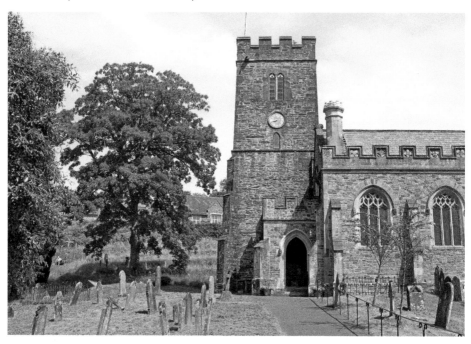

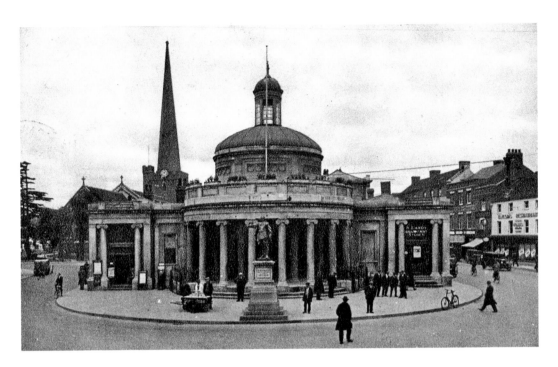

Bridgwater, Cornhill, c. 1935

Bridgwater lies on the River Parrett about ten miles north of Taunton. Here in the town centre we look across Cornhill to the Market Hall, built in 1834, with the tower of St Mary's church behind. In the old photograph there is a statue in front of the Market Hall. This is of Admiral Robert Blake, who was born in the town in 1598 and who later reorganised the navy in the time of Oliver Cromwell. The statue has since been moved into nearby Fore Street, and so outside my shot.

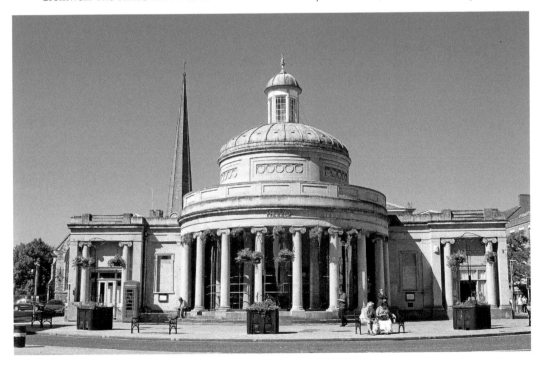

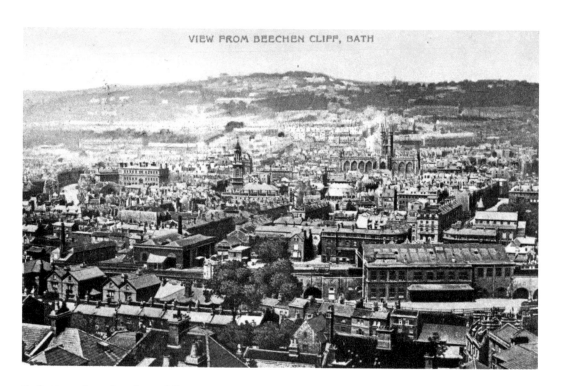

Bath, Seen from Beechen Cliff, *c.* 1900

Now quite a leap over to the north-east of the county, to the Roman, medieval and Georgian city of Bath. These photographs were taken from different locations on Beechen Cliff to the south of the city, where Alexandra Park was opened in 1902. The square-towered abbey is on the right in both photographs. The prominent tower in the centre of the old view belonged to the church of St James, demolished in the 1950s after it, and much of the area around, was damaged by Second World War bombing.

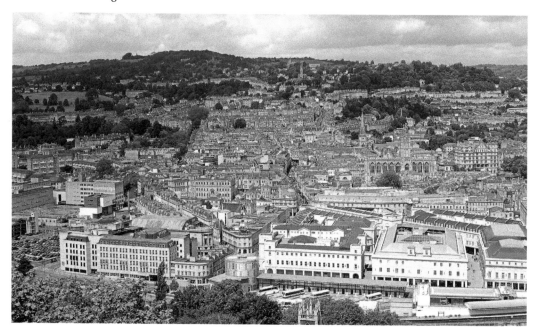

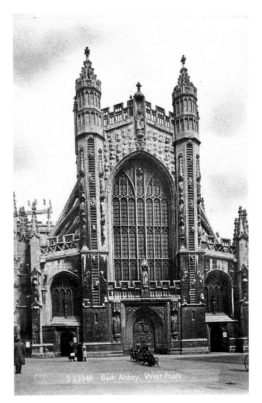

Bath, The Abbey, *c.* **1920**

Down into the city to see Bath Abbey. Here we look at the West Front from the busy little square that has the Roman Baths on one side. Construction of the present building began in 1499 and it was over a century before the work was finished, partly because it was interrupted by the religious turmoil of the Reformation.

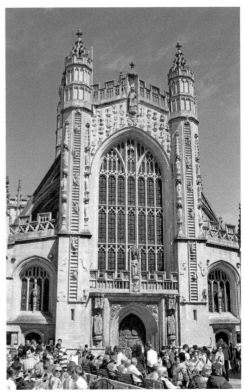

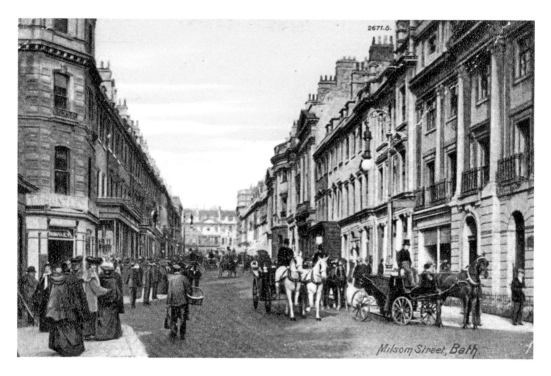

Bath, Georgian Buildings in Milsom Street, *c.* 1900

Bath had been known for its spa previously, but visits by Queen Anne in the early 1700s, then the social organisation of Beau Nash and the entrepreneurial skills of the mayor and MP Ralph Allen made it into a fashionable and rapidly expanding city. The architect who designed much of the new development was John Wood the elder. Milsom Street, to the north of the abbey, was one of his designs, although it was not constructed until around 1762, eight years after his death.

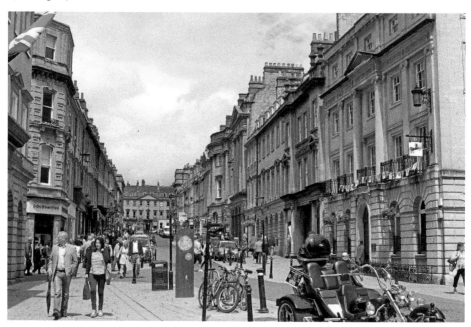

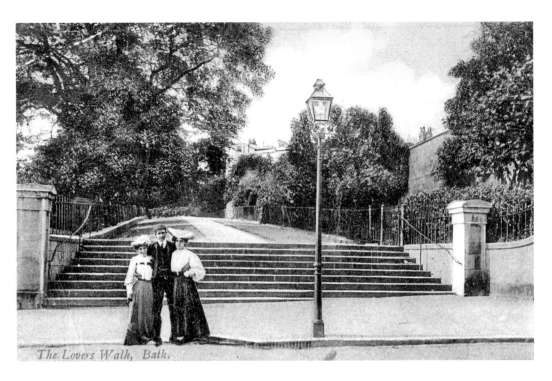

The Lovers Walk, Bath.

Bath, Gravel Walk, c. 1905

Now we head a couple of streets to the west, to a spot just north of Queen Square. Here is one end of the Gravel Walk, which was laid out in the Georgian period to link the city centre with Royal Crescent and the new suburbs further out. It was designed with the sedan chairs of the wealthy suburbanites in mind, and its regular use by lovers such as two characters in Jane Austen's novel *Persuasion* meant that it was sometimes called 'Lovers' Walk'.

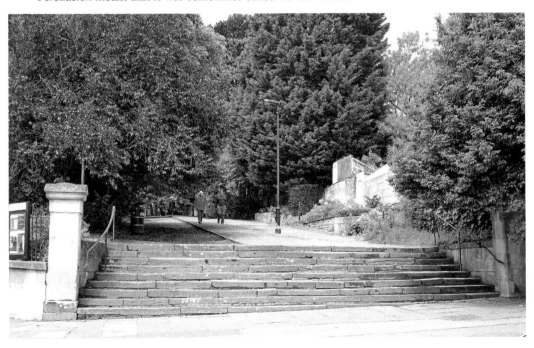

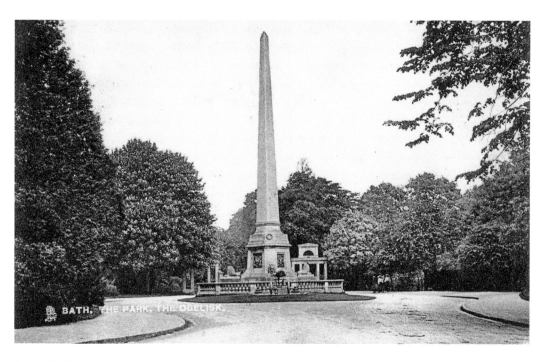

Bath, Obelisk, *c.* 1900

Royal Avenue begins just around the corner from the previous viewpoint and heads west through Royal Victoria Park. One of the earliest public parks in the country, it was formally opened in 1830 by the future Queen Victoria, who was so impressed that she allowed it the rare privilege of being called 'Royal'. We head some way along the avenue and turn around for this view of the 'Victoria Majority Monument', which was erected in 1837, the year she became Queen.

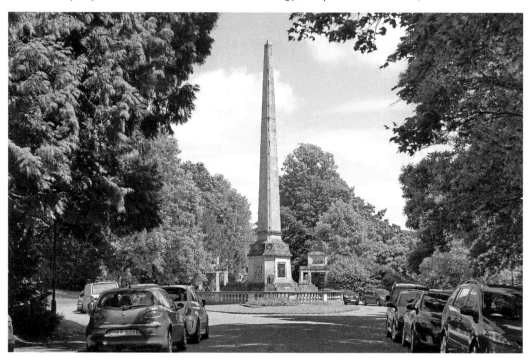

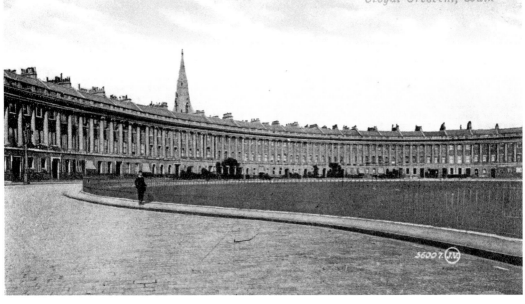

Bath, Royal Crescent, c. 1910

Next we head back a short distance and go uphill to see one of the most famous sights in Bath. Royal Crescent was built between 1767 and 1774 to the design of John Wood the younger, who continued his father's work in developing the town. One difference between these shots is the disappearance of the tower of St Andrew's church in the background. It too was demolished after suffering wartime bomb damage.

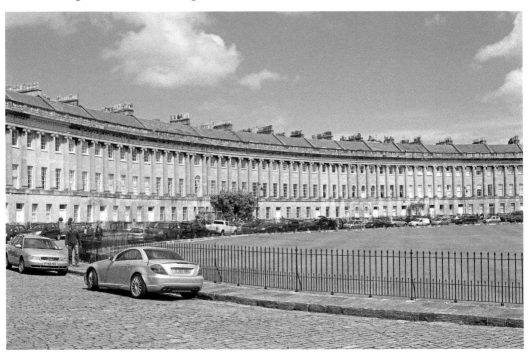

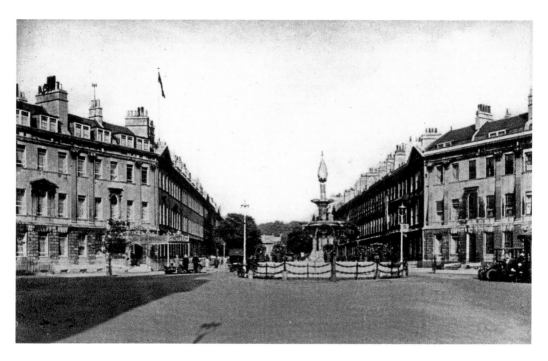

Bath, Pulteney Street, *c.* 1925

Before we leave Bath we travel across the city and go over Pulteney Bridge to the Bathwick suburb on the east side of the Avon. Development here began in the last years of the eighteenth century after the death of the Woods. This view looks up Great Pulteney Street, and the scene (with the obvious exception of the postbox!) looks rather French. Note how the fountain has been altered.

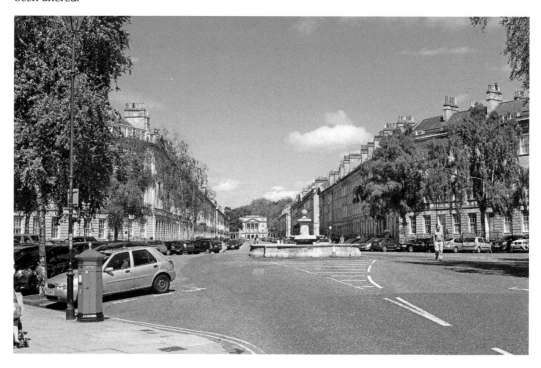

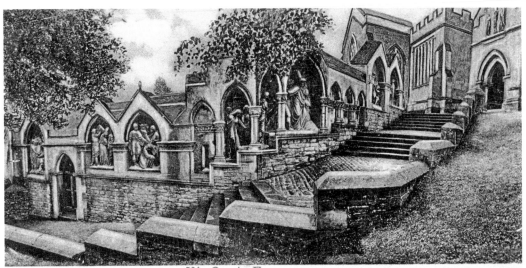

Via Crucis, Frome.
This beautiful series of carvings, representing scenes from Our Lord's Passion, is at the North entrance to St John's Church.

Frome, Via Crucis, *c.* 1905

Next we head some way south to Frome near the eastern end of the Mendip Hills. In 1860, these sculptures were erected beside the path that leads up to the north porch of the parish church. Their Latin title translates as 'The Way of the Cross', and they illustrate the narrative of the Crucifixion.

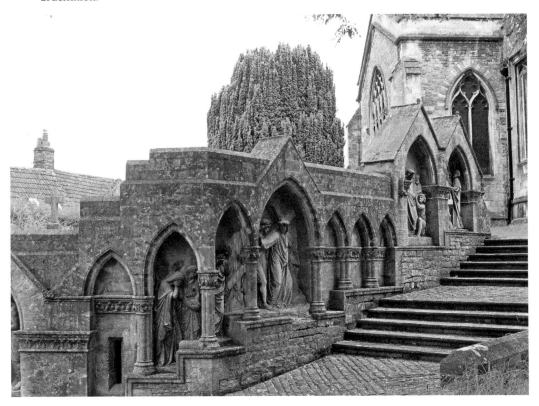

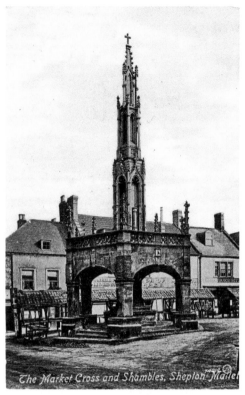

The Market Cross and Shambles, Shepton Mallet

Shepton Mallet, Market Cross, *c.* 1900
Ten miles to the west is the market town
of Shepton Mallet. The Market Cross dates
from the year 1500, and is made of Doulting
Stone, a local limestone. The names of those
who paid for the Cross, William and Agnes
Buckland, are recorded on a plaque that is
attached to it. The Cross is in the market area
known as The Shambles, originally a name
for a butchers' market; because the processing
of meat left a lot of waste around, the word is
now used for any disorganised mess.

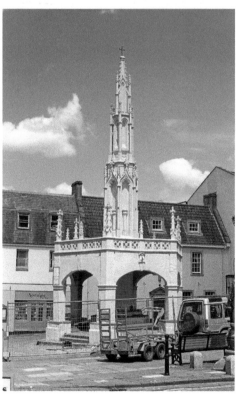

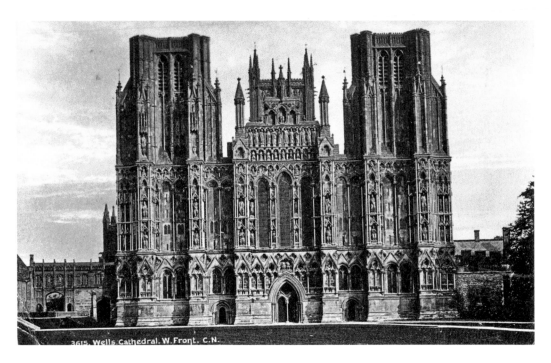

3615. Wells. Cathedral. W. Front. C.N.

Wells, The Cathedral, *c.* 1900

Six miles further west takes us to England's smallest city. Wells has a superb location beneath the Mendips, and the best of its many historic buildings is the cathedral. Most of the building was constructed between 1176 and 1239, though the towers were added during the next two centuries. In this view we look across the Cathedral Green to the west front.

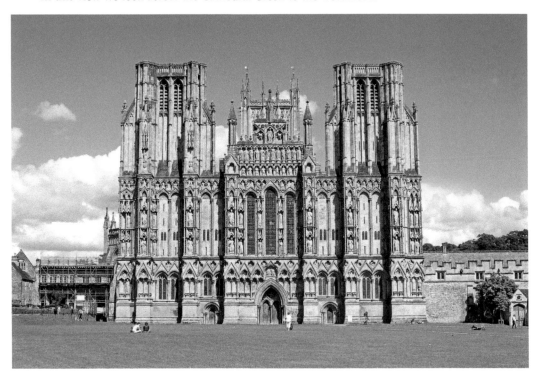

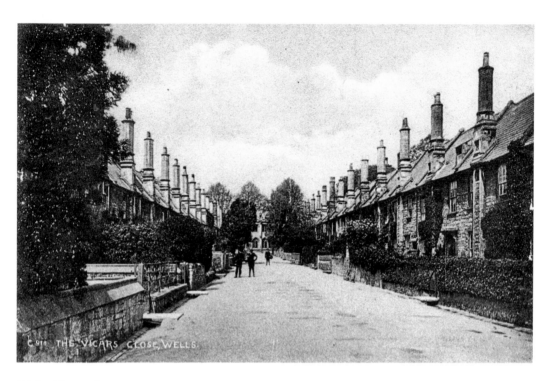

Wells, Vicars Close, *c.* 1910

This is a remarkable survival just north of the cathedral. It was built around 1348 to house officials of the cathedral. Externally at least, the buildings appear relatively unaltered, although even over the past century some things have changed – most obviously some of the garden walls.

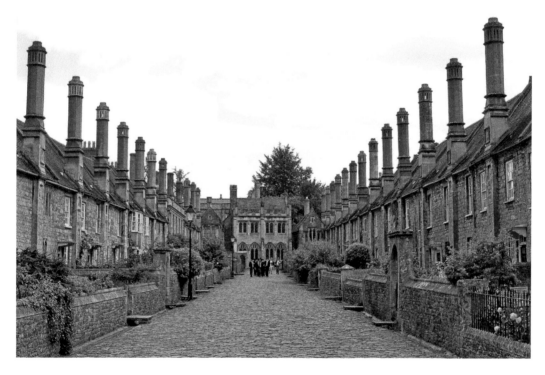

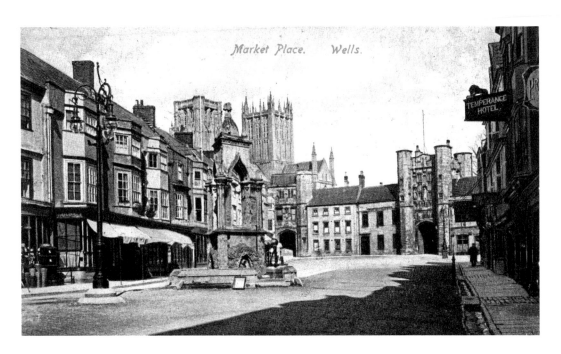

Wells, Market Place, *c.* 1905
Next we head back across the Cathedral Green to the Market Place for this attractive view. In the foreground is a fountain dating from 1793, built over one of the three wells that gave the city its name. Beyond there are several buildings all built by a local bishop around 1450. These include the row of properties to the fountain's left, the Penniless Porch which is behind it to the right, and further to the right the Bishop's Eye gatehouse that leads to the Bishop's Palace.

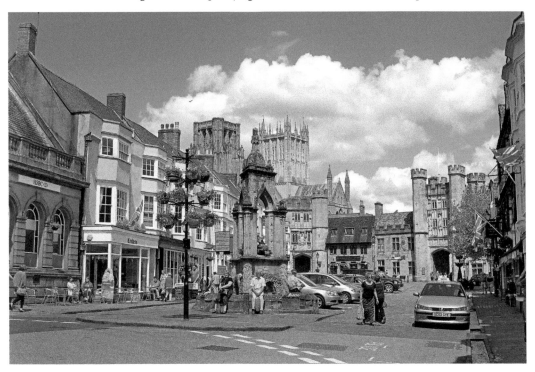

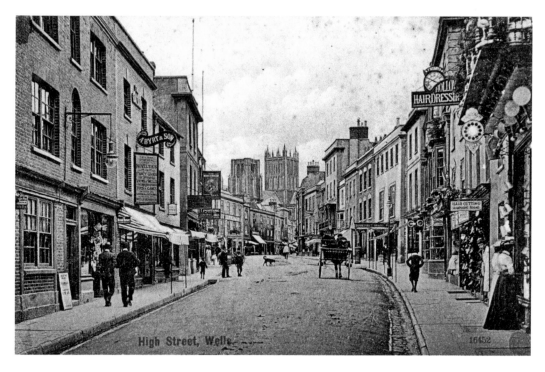

Wells, High Street, *c.* 1905
Here we look back towards the Market Place and cathedral from partway down the High Street. Most of the buildings we see date from the eighteenth and nineteenth centuries, and they generally seem unchanged except at ground-floor level, where a variety of modern shopfronts have been added.

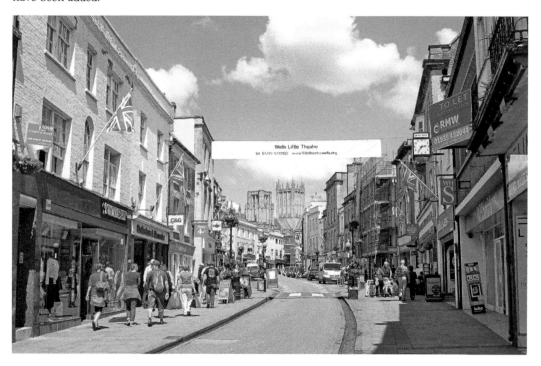

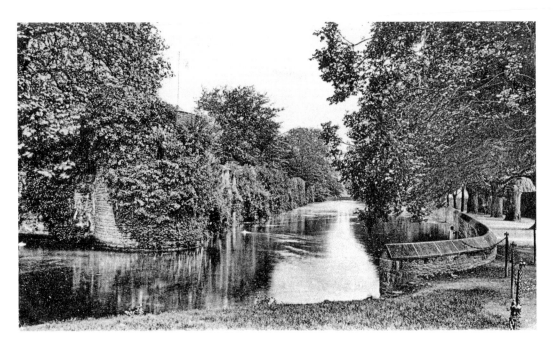

Wells, Moat of The Bishop's Palace, *c.* 1900

Going back to the Market Place, we go through the Bishop's Eye gatehouse to look at the moat that surrounds the medieval Bishop's Palace. Comparing the two photographs we see that much of the attractive, but damaging, foliage has been removed from the Palace's curtain wall on the left. The moat is famed for its population of swans, and my photograph shows part of a public arts event, when sixty swan sculptures were set up around the city.

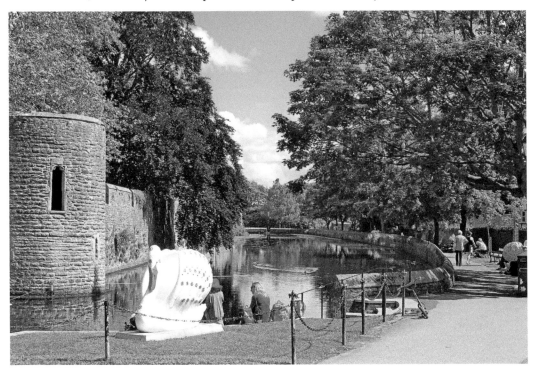

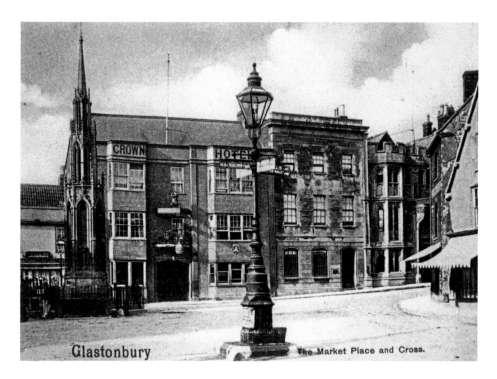

Glastonbury, Market Place, c. 1905

Glastonbury is five miles south-west of Wells and is equally historic and popular with visitors. Here we look across the central Market Place towards The Crown Hotel. On the left is the Market Cross, erected in 1846 as a copy of and replacement for a medieval predecessor. To the right we see part of the George Hotel, about which more later.

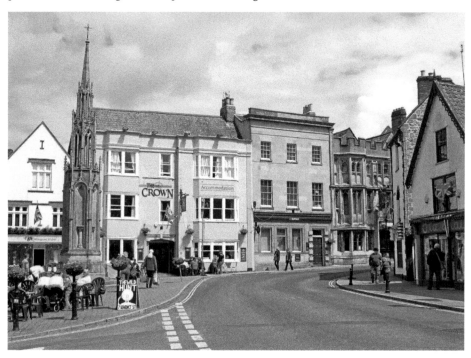

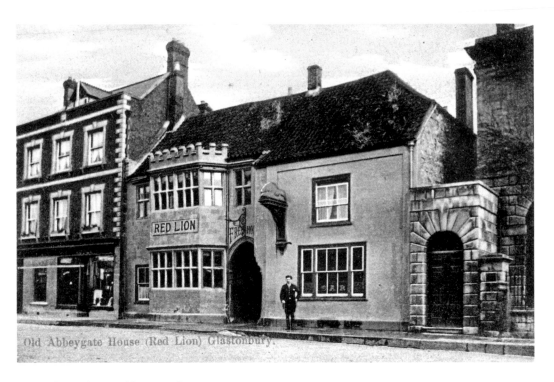

Old Abbeygate House (Red Lion) Glastonbury.

Glastonbury, Abbey Gatehouse, *c.* 1900

We are now in Magdalene Street, a few yards from the Market Place, to see a rather significant alteration! The central building dates from the fourteenth century and was originally the gatehouse to the Abbey. It later became the Red Lion pub. The Abbey ruins became a tourist attraction in Victorian times, and at some point in the early twentieth century an archway was knocked through the building to form a new entrance to those ruins.

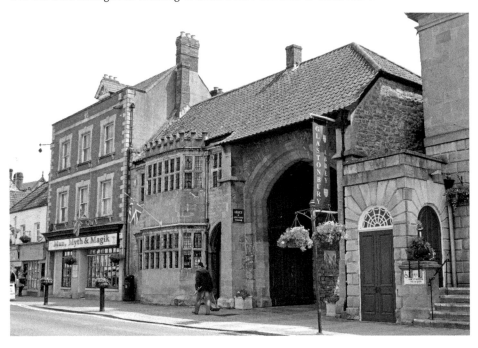

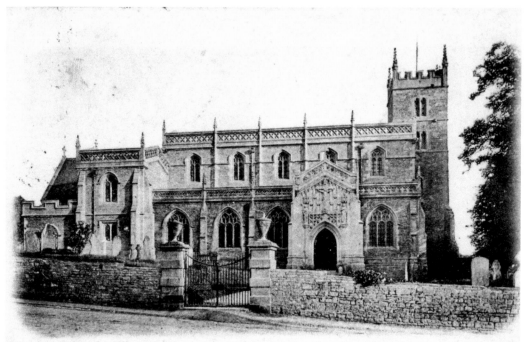

Parish Church, Wincanton.

Wincanton, Parish Church of St Peter & St Paul, *c.* 1900
Now across to the south-east, almost to the borders of Wiltshire and Dorset. Wincanton is a small market town (with a population of less than 5,000) on the edge of the Blackmore Vale that is probably best known for its racecourse. Here is its parish church, which was rebuilt in Victorian times.

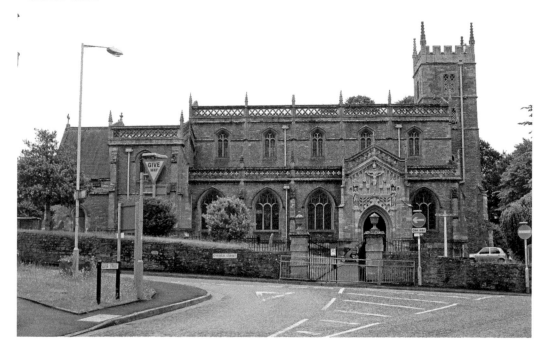

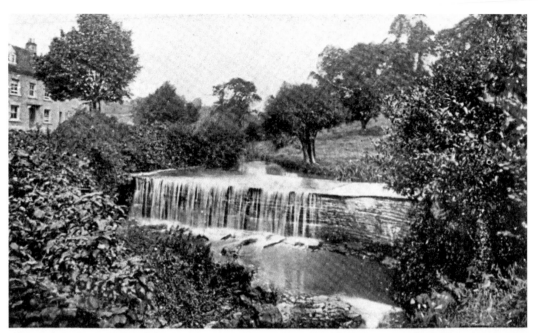

The Weir, Wincanton.

Published by C. E. Watling, Wincanton.

Wincanton, Weir, *c.* 1905

Wincanton lies on the River Cale, a tributary of the Stour that flows into the English Channel by Christchurch in Dorset. This weir lies on the north side of the town at the end of North Street, and I found it in full spate after heavy overnight rain.

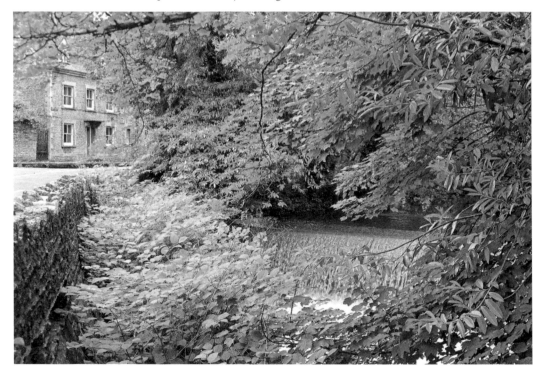

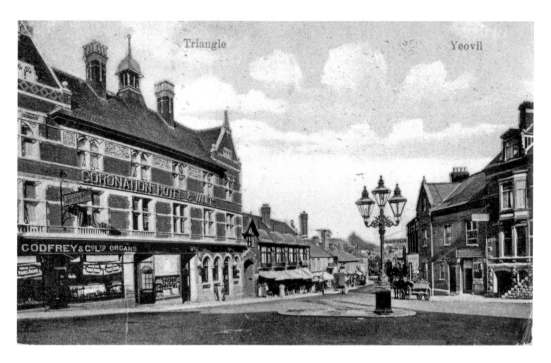

Yeovil, Triangle, c. 1905

Ten miles south-west now and we are in Yeovil. The viewpoint here is the Triangle, where South Street comes in from our right to meet Middle Street, and we are looking down Lower Middle Street. Twentieth-century redevelopment has changed the view a great deal, although some of the further buildings on the right are just recognisable. The Coronation Hotel is on the left in the old view – it was built around 1900 on the site of another pub, and was itself demolished in the 1960s.

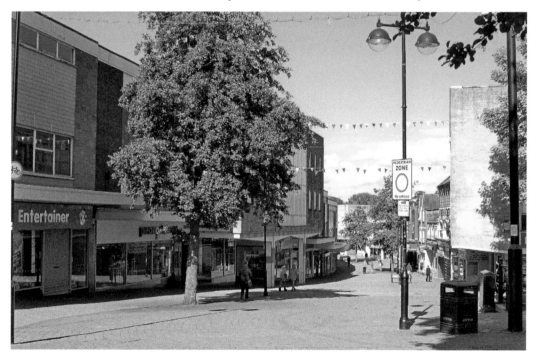

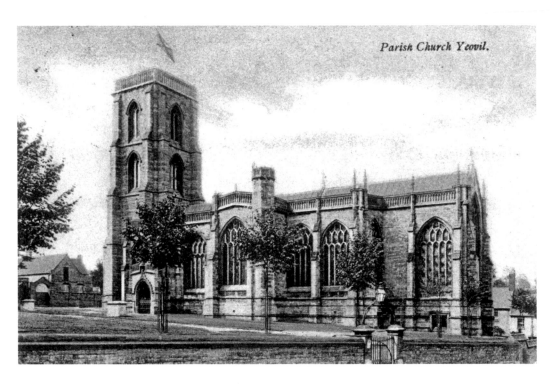

Parish Church Yeovil.

Yeovil, A 'Lost' View of the Parish Church, *c.* 1905
Up Middle Street now and at the top around the corner into Silver Street to see the fourteenth-century church of St John the Baptist. Today a row of lime trees obscures the view, and in the old picture we see what are probably youthful versions of the same trees, protected with tree guards, which suggest they had been planted quite recently.

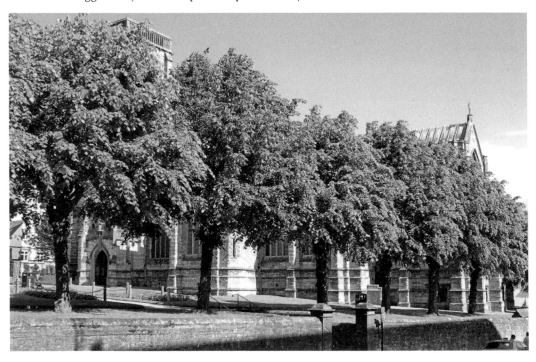

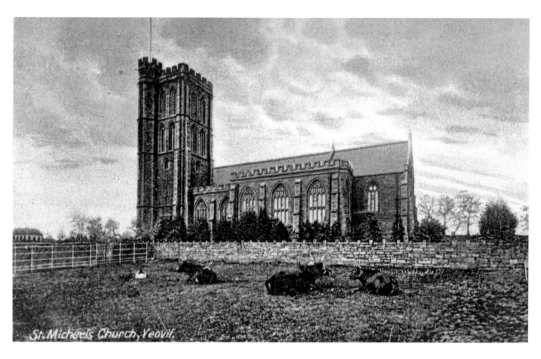

St. Michaels Church, Yeovil.

Yeovil, St Michael & All Angels Church, *c.* 1905

Here is another of Yeovil's churches in a rather different location. The old picture of St Michael & All Angels was taken only a few years after it opened in 1897, and shows it in a rural setting. The church must have been built as an advance guard ready to serve the expanding eastern suburbs of Yeovil, which have long since enveloped it.

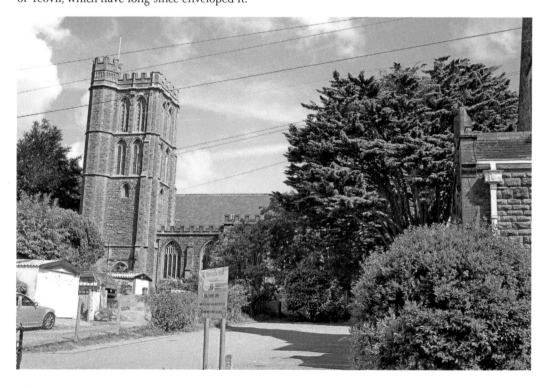

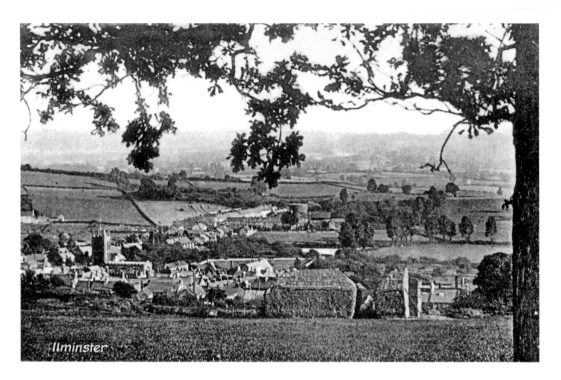

Ilminster, View Across the Town, *c.* 1910

Now we head some twelve miles west to the market town of Ilminster. The viewpoint here is on Beacon Hill on the north side of the town, and we look across towards the hills on the county boundary. The considerable expansion over the past century on the south side of the town around Listers Hill is clear from this angle.

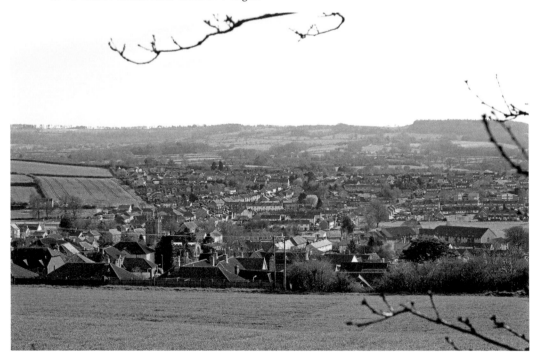

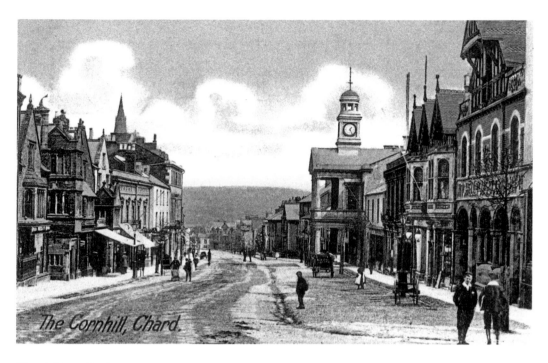

The Cornhill, Chard.

Chard, Town Centre, c. 1900

Five miles further south still brings us to the last town in this chapter, and the most southerly in Somerset. One thing I particularly like about Chard is its association with the history of powered flight – in 1848 a local man John Stringfellow flew a steam-powered model for a short distance. Here we look downhill from the corner of the High Street and Holyrood Street; the building on the right with the clock tower is called both the Guildhall and the Town Hall.

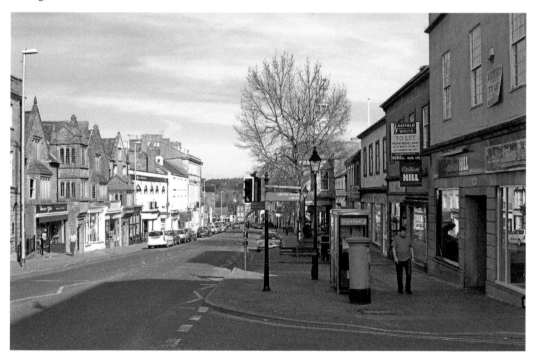

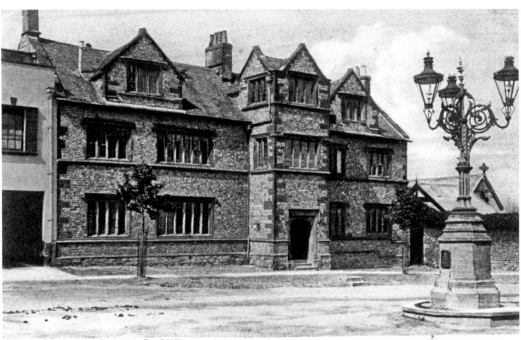

THE GRAMMAR SCHOOL, CHARD.

Chard, Chard School, c. 1900

Down the hill in Fore Street we find Chard School. The building we see here dates from 1583, and was originally a private residence. In 1671, William Symes, the grandson of the first owner, sold it to the town as a grammar school, and it has been a place of education ever since. A lamp that was erected to celebrate Queen Victoria's Golden Jubilee of 1887 is on the right in the old view.

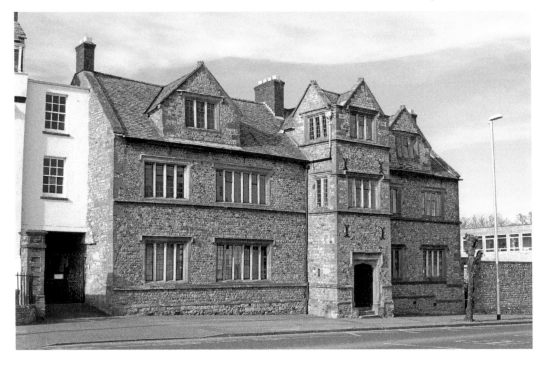

Coastal Towns

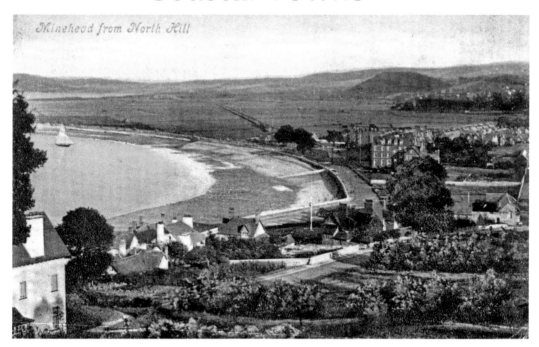

Minehead, View from North Hill, *c.* 1905

In this chapter we take a trip along the coast starting over in the west at Minehead and working our way along the Bristol Channel. When the old picture was taken, Minehead was expanding apace, with a wealthy suburb developing on the side of North Hill. Looking at my picture (taken from the only viewpoint here that I could find), you can see also how Minehead has expanded out into the flatter land to the east. The isolated hill in the distance is the one on which Dunster Castle sits.

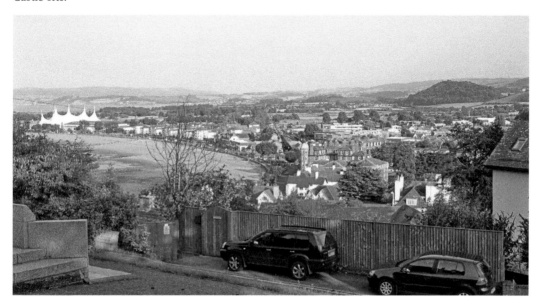

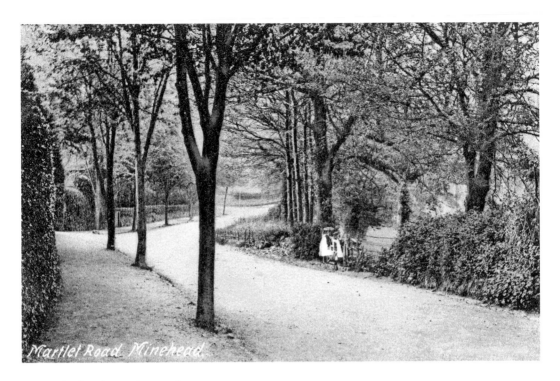

Martlet Road, Minehead.

Minehead, Martlet Road, c. 1900

Here in Martlet Road, which runs up North Hill, we see some of that suburban expansion. The walls on the left in the old view suggest that there were already houses on this side, but across the road the scene is still rural. The War Memorial and its gardens that were constructed at the junction with St Michael's Road after the First World War are in the background of my shot.

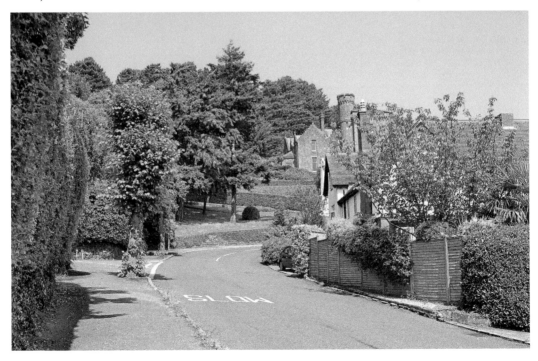

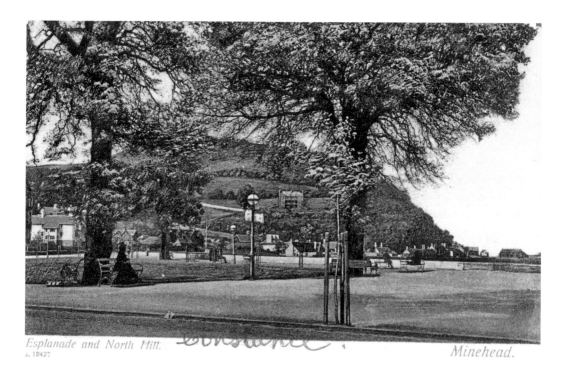

Esplanade and North Hill.
J. 12437
Minehead.

Minehead, Esplanade and North Hill, *c.* 1900

Now we go down to the seafront and look back towards North Hill from close to the railway station, which is operated today by the West Somerset Railway. The area to the lower right of the hill is Quay Town, one of the three historic districts of Minehead – the others being Higher Town and Lower Town.

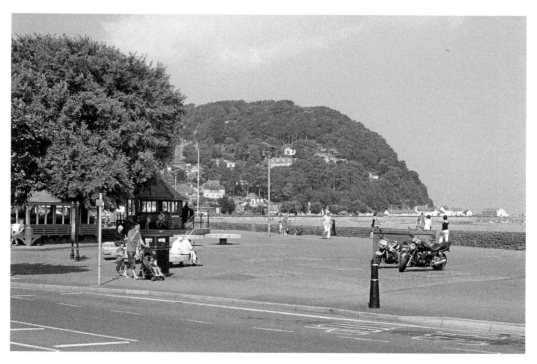

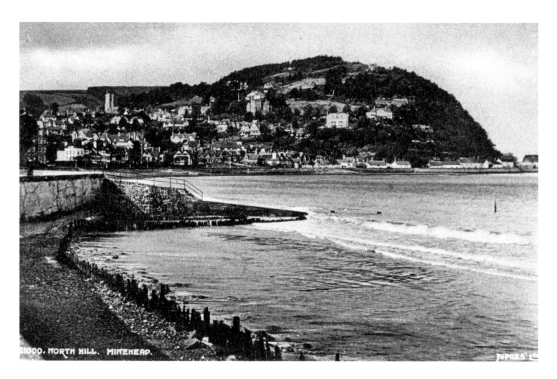

Minehead, Wider View of North Hill, *c.* 1910

We move away from North Hill but continue to look back at it. This historic picture was taken a decade or so after the previous one and more houses have sprung up on the distant hillside. This wider view also includes Higher Town on the left, where the tower of St Michael's church is prominent. Lower Town is out of view yet further to the left.

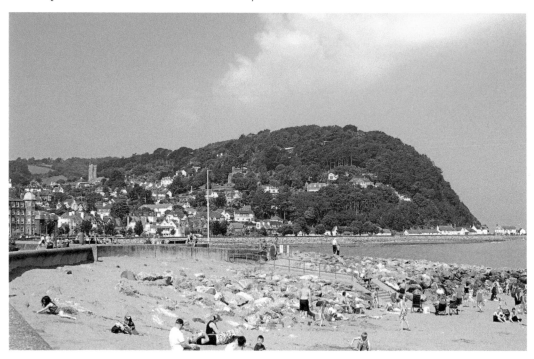

43

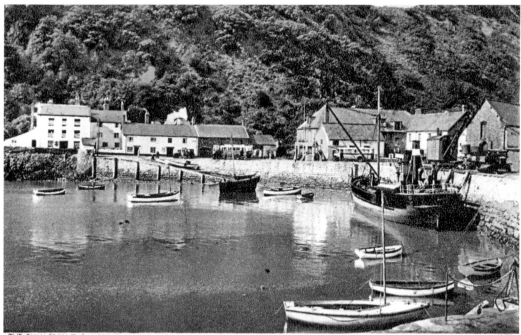

THE QUAY FROM THE HARBOUR. MINEHEAD

18455

Minehead, Quay Town from the Harbour, c. 1930
Turning back, we head along the seafront and go out onto the harbour to look back at the historic and attractive Quay Town area. Although there had been a port here before, it was not until 1616 that the stone harbour wall was constructed.

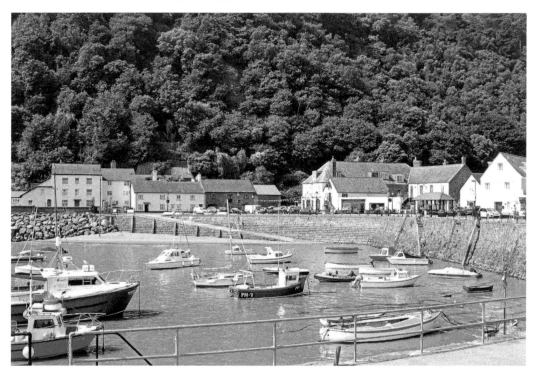

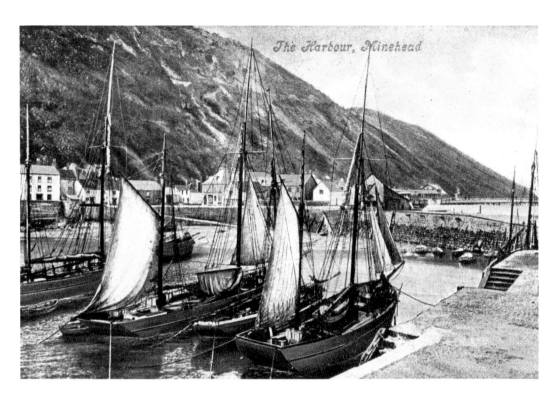

The Harbour, Minehead

Minehead, the Harbour and North Hill, c. 1900
From close to the point where the previous views we taken, we turn around somewhat to face west. The harbour wall was enlarged in 1901, but I am not sure whether the old photograph was taken before or after this. Beyond, we see the slopes of North Hill, today with much more tree cover.

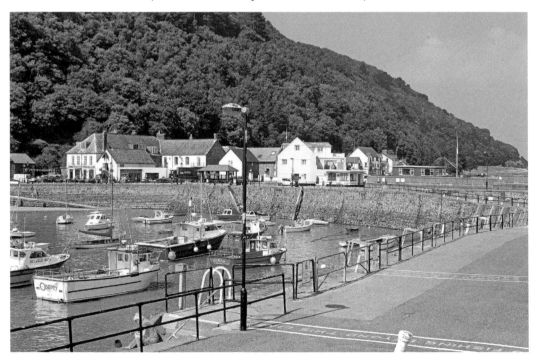

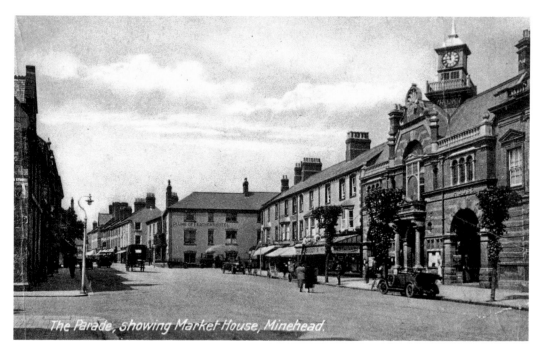

The Parade, showing Market House, Minehead.

Minehead, the Parade and Market House, c. 1920

Next we head over into Lower Town, much of which was destroyed in a fire in 1791. Today it is the main shopping area. Here we see The Parade, a short section of road that is a continuation of the High Street. The building on the right with the little tower is the Market House, dating from 1902 and which now houses a café, the town hall and a shop.

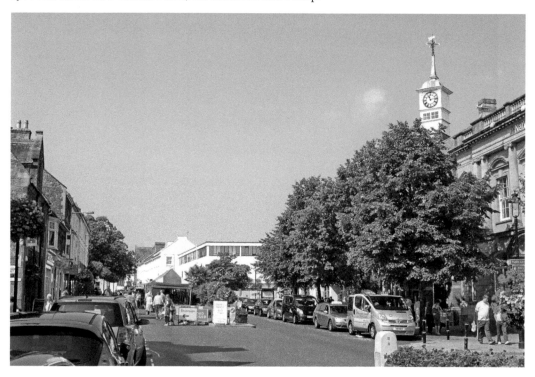

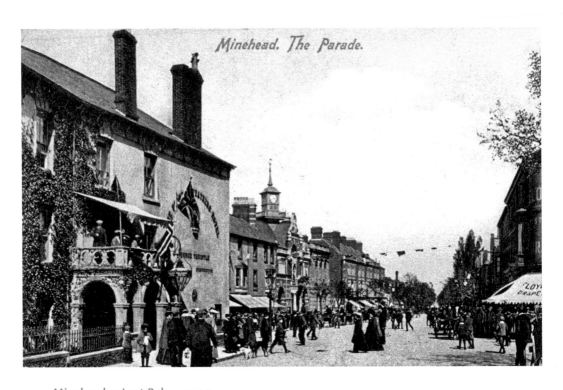

Minehead. The Parade.

Minehead, a Lost Pub, c. 1905
We head a little way past The Parade into Park Street and turn back to look towards the Market House. The building on the left in the old picture is the Plume of Feathers Hotel, which was demolished in 1965.

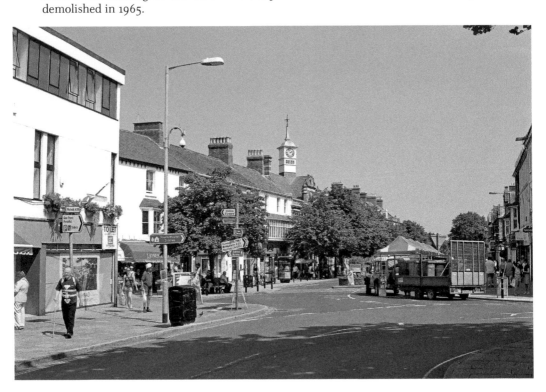

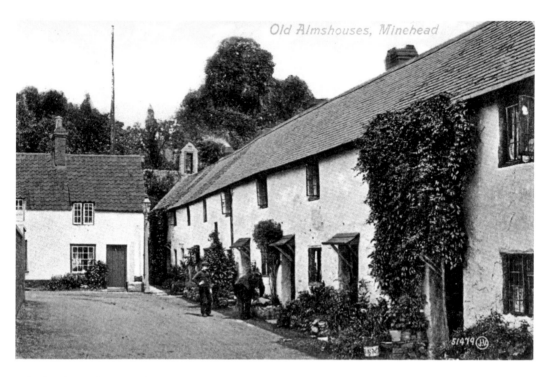

Old Almshouses, Minehead

Minehead, Quirke's Almshouses, c. 1905

Market House Lane runs behind the Market House, and it is here that we find a survivor of the fire, a row of cottages called Quirke's Almshouses. They were donated to the town in 1630 by Robert Quirke, a sailor, in thanksgiving after his ship survived a storm. There is a bell on the roof of the cottage at the far end, which may have been used to summon the occupants to prayers.

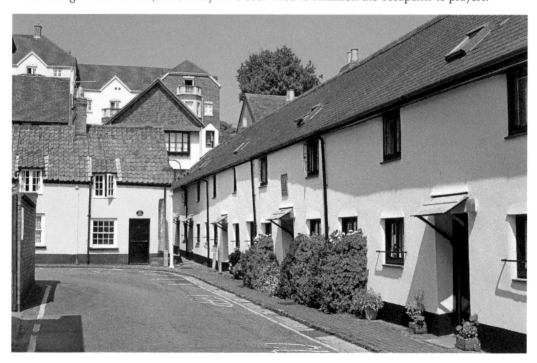

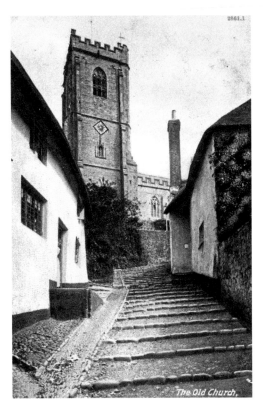

The Old Church,

Minehead, St Michael's from Church Steps, c. 1905

Now up to Higher Town. There was no devastating fire in Higher Town, so there are a fair number of old buildings such as the two we see in this view. We are looking up Church Steps which lead to the late medieval parish church. This prominent landmark of the town is well worth a visit – I particularly liked the door within a door inside the south porch!

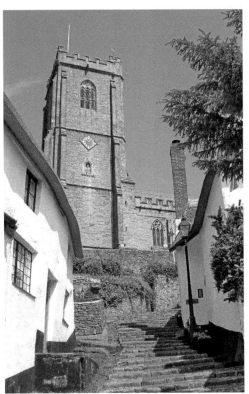

Minehead, Church Steps, c. 1925
For our last view in Minehead we simply
climb a few more steps and turn around. The
nearest two properties are the same as those
in the previous view, and beyond we look
across the town to the hills of Exmoor.

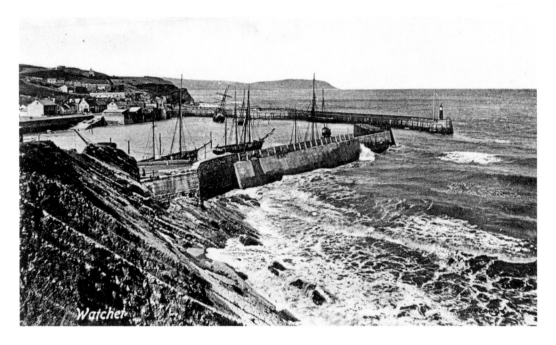

Watchet, Harbour, *c.* 1905

We travel about eight miles east to the smaller town of Watchet. Its natural harbour was important for trade from early times, and artificial piers and walls were added in the eighteenth and nineteenth centuries. In 1797 the harbour inspired Samuel Taylor Coleridge to write *The Rime of the Ancient Mariner*. The manmade structure was badly damaged in a storm in 1900, and had to be rebuilt extensively. The old photograph was probably taken a few years after this.

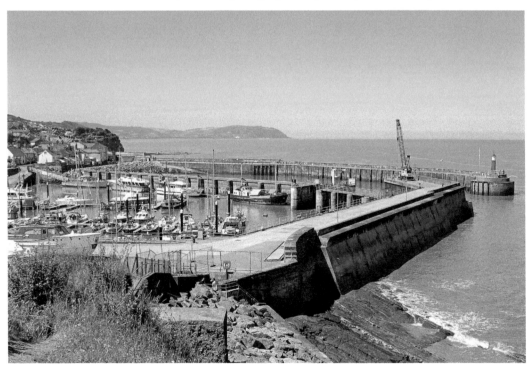

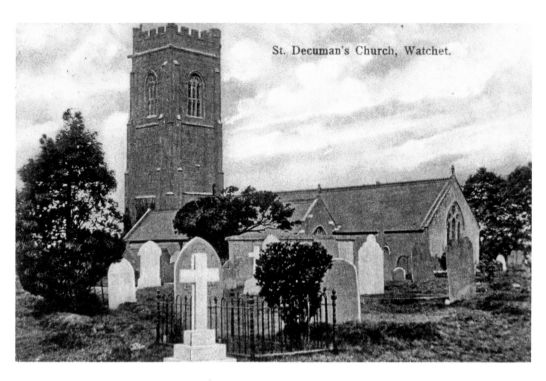

St. Decuman's Church, Watchet.

Watchet, St Decuman's Church, *c.* 1900

St Decuman was a Welsh saint who crossed the Bristol Channel in the seventh century or perhaps earlier and settled at Watchet. The church dedicated to him lies in what is almost a separate village on the edge of the town. It looks as though the little yew in the foreground of the old picture has grown a great deal in the past century!

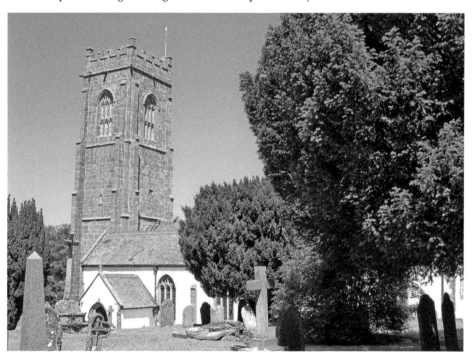

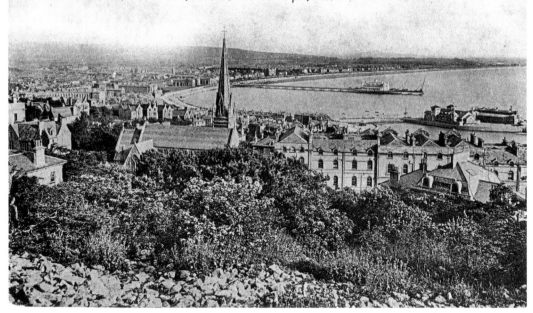

Weston-super-Mare from the Encampment. H. B. & Son, B

Weston-super-Mare, View of the Town, c. 1905

We continue along the coast, leaving Burnham-on-Sea for later, and head in a more northerly direction to Weston-super-Mare. The old view looks south across Weston Bay from Worlebury Hill with the spire of Holy Trinity in the foreground. Trees now block this view, and my photograph was taken from partway up the hill nearer the town centre. Nevertheless, the town's considerable expansion inland can be made out.

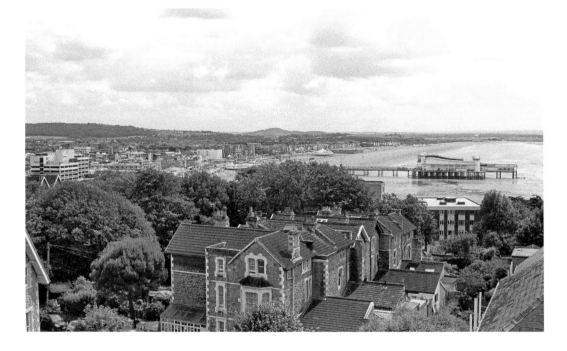

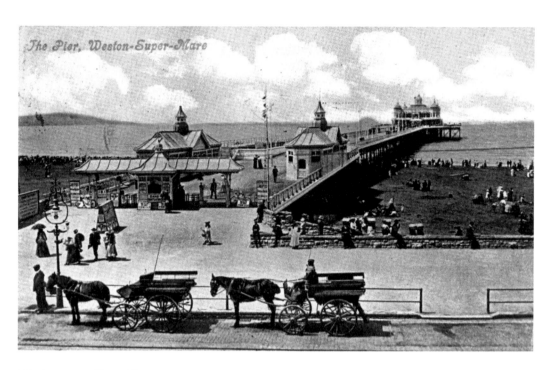

The Pier, Weston-Super-Mare

Weston-super-Mare, Pier, c. 1905

Now we start a sequence of views that takes us on a short tour along the seafront starting at the pier, which has changed a great deal over the years. The old photograph was taken within a couple of years of the pier's opening in 1904. The pavilion at the end was destroyed in a fire in 1930 and had to be rebuilt. There were other alterations over the next decades, and then in 2008 another fire caused major damage, especially to the pavilion. The pier reopened in 2010 and now contains a theme park.

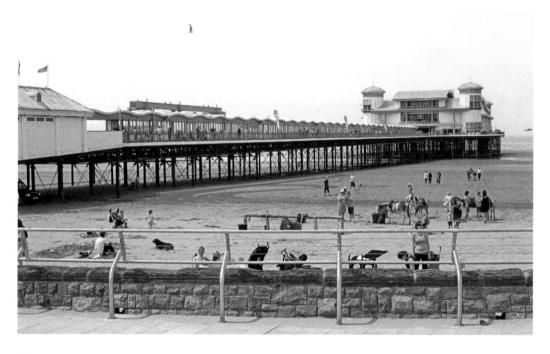

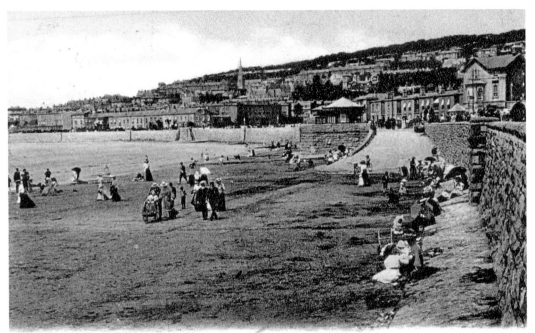

North View, Weston-Super-Mare

R. Hopwood, Weston s. Mare.

Weston-super-Mare, North View, c. 1905

Next we turn back to Worlebury Hill and move a little closer for our next viewpoint. Although some of the details have altered over the past century, the general scene has not changed. Weston-super-Mare developed rapidly as a seaside resort during the nineteenth century, and by the century's end the seafront had filled with buildings, and many of the well-to-do had residences on the side of Worlebury Hill.

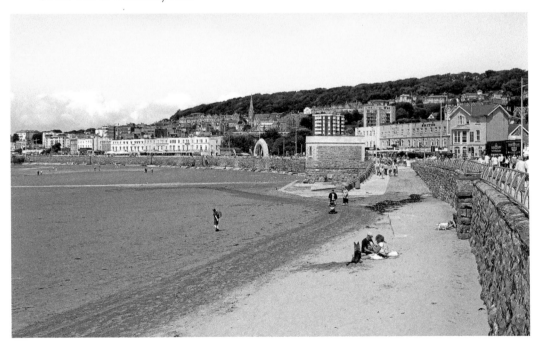

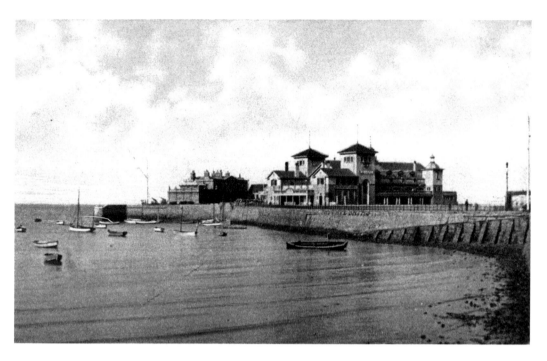

Weston-super-Mare, Knightstone Pavilion and Baths, *c.* 1905

We move to a spot by the left-hand edge of the previous pictures and look across to Knightstone Island. The construction of medicinal baths here in the 1820s helped the early growth of Weston-super-Mare as a resort, and soon after came a causeway to the island and the house on the left, built for the next owner. The Pavilion that is the largest building in the old picture was added in 1902. In recent years, there has been a residential conversion with additional building.

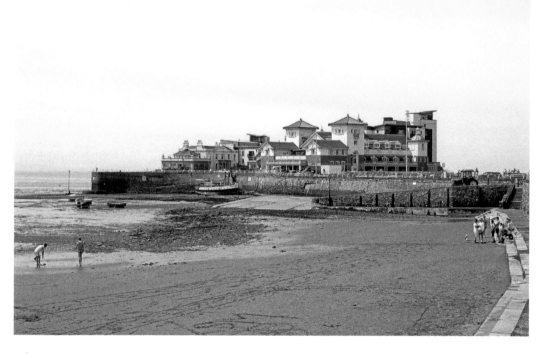

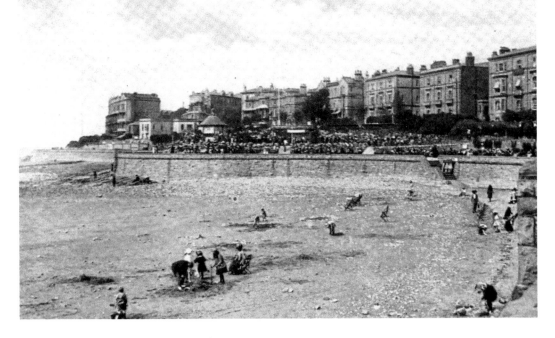

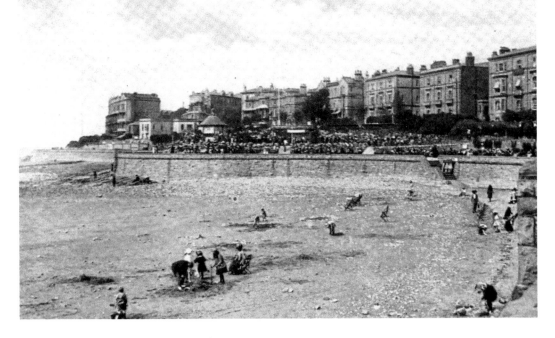
E. 46460. WESTON-SUPER-MARE: KNIGHTSTONE SANDS.

Weston-super-Mare, a New Lake, *c.* 1910

A little further on just past the causeway to Knightstone and we see quite a changed view, and it is not simply that I took my photograph when the tide was in. In 1928 the Marine Lake was constructed for recreational purposes in this little bay. The end of the causeway that separates the lake from the sea is just visible on the left side of my picture.

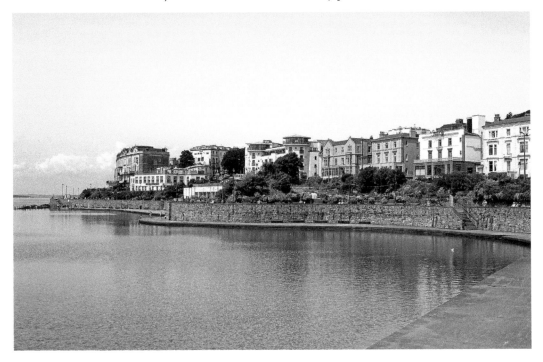

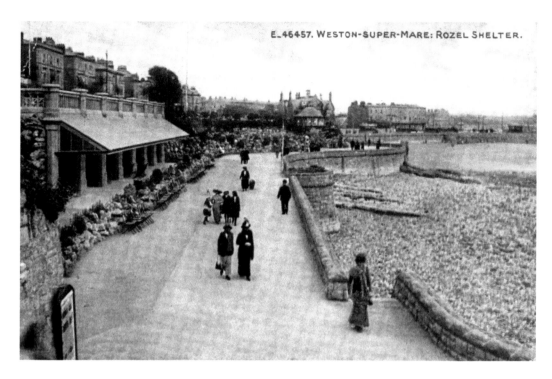

Weston-super-Mare, Rozel Shelter, *c.* 1910

We head across to the other side of the Marine Lake and turn back. The shelter on the left in the old view and more of the seafront were badly damaged in a storm of December 1981, necessitating much rebuilding here and elsewhere. The building we see today is The Cove restaurant.

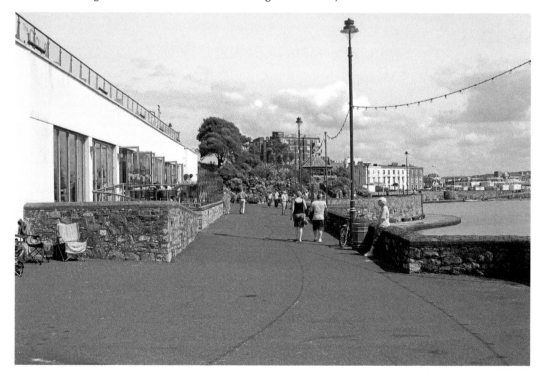

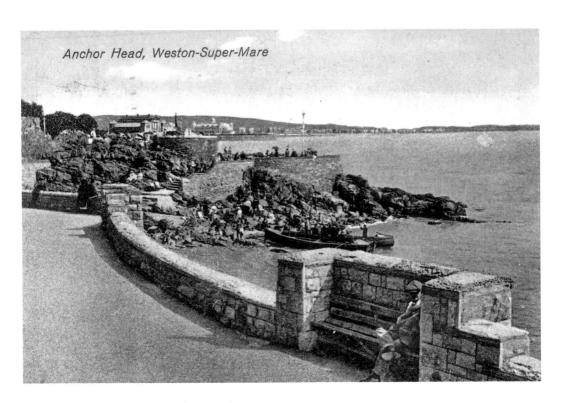

Anchor Head, Weston-Super-Mare

Weston-super-Mare, Anchor Head, *c.* 1925

A couple of hundred yards further on and again we look back. Here at Anchor Head there are some rather ornate sea defences around the rocky headland, from which there is a good opportunity to admire the sweep of Weston Bay.

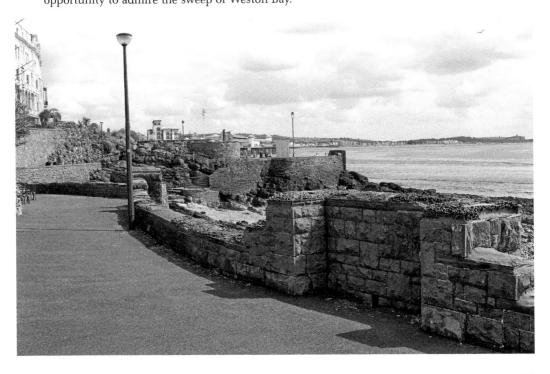

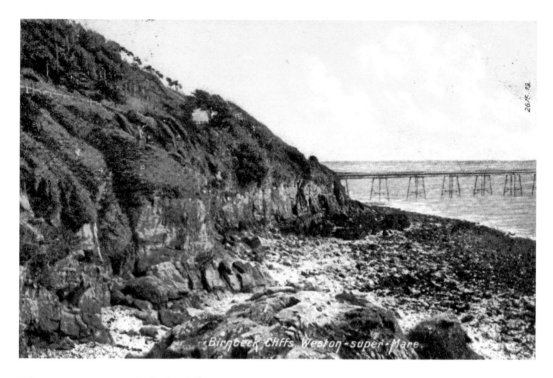

Weston-super-Mare, Birnbeck Cliffs, *c.* 1900

We continue around the headland, and in this next view we are on the other side of Worlebury Hill from the town. We look back to see the limestone of Birnbeck Cliffs and the pier to Birnbeck Island that was built in 1867. From the opening of the pier until 1994, ships, many coming from South Wales, landed their passengers at a jetty on the island. A lifeboat has operated from Birnbeck Island since 1882.

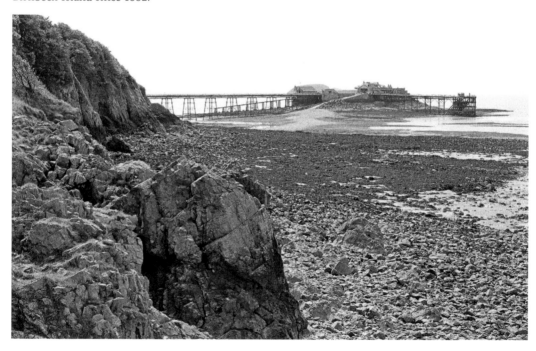

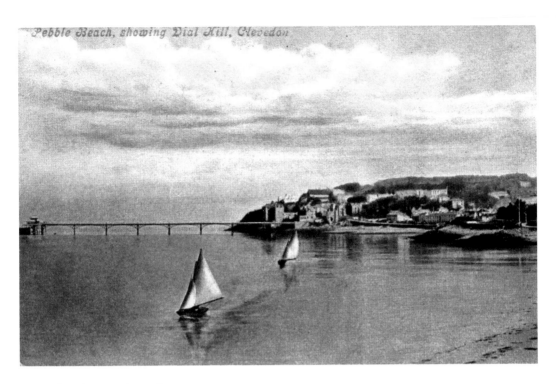

Pebble Beach, showing Dial Hill, Clevedon

Clevedon, Marine Lake, *c.* 1900

Clevedon is about eight miles up the coast from Weston-Super-Mare, and it too expanded considerably in the Victorian holiday boom. The town is proud that like Rome it is built on seven hills, and here we look towards the centre, with Dial Hill on the right and the pier constructed in 1869 on the left. Clevedon's Marine Lake was also constructed in the late 1920s and it is in the foreground of my photograph.

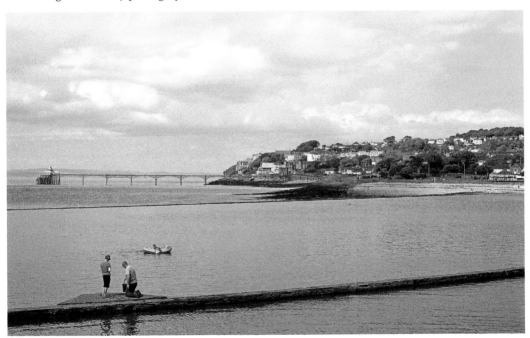

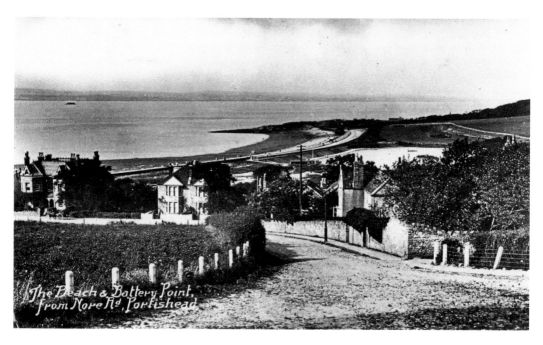

Portishead, Beach and Battery Point, *c.* 1910

Some six miles further along and we are at Portishead, almost the end of the Somerset coast. This was another old fishing settlement that grew considerably in the nineteenth century, as the result of both tourism and a new dock, in both of which it was helped by its proximity to Bristol. Looking down Beach Hill from its junction with Nore Road, the old picture shows what were then quite new seaside villas. In the distance is Battery Point.

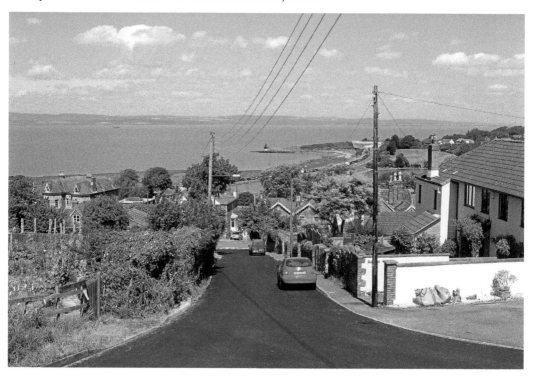

Villages

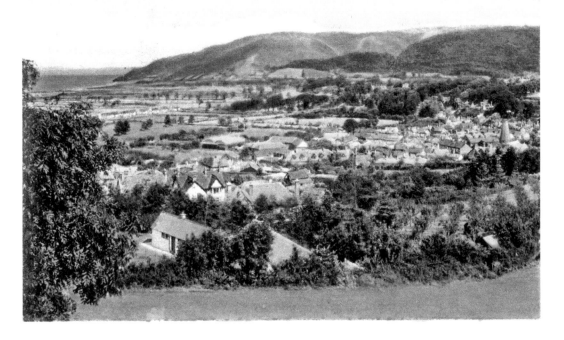

Porlock, View from the South, *c.* 1905

Next a look at some of Somerset's many charming villages, arranged in a west-to-east fashion. We begin with one of the best-known, Porlock, which lies about halfway between Minehead and the Devon border. The old picture was taken from Porlock Hill, mine from a little further east, but they both show the lovely setting of the village, with Bossington Hill in the background.

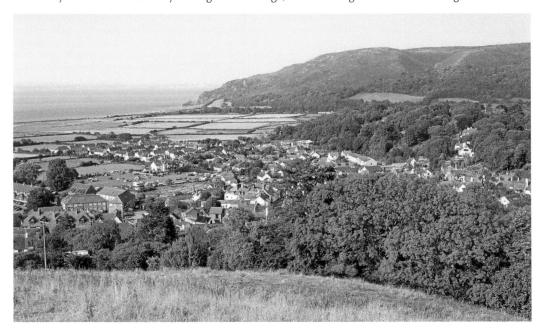

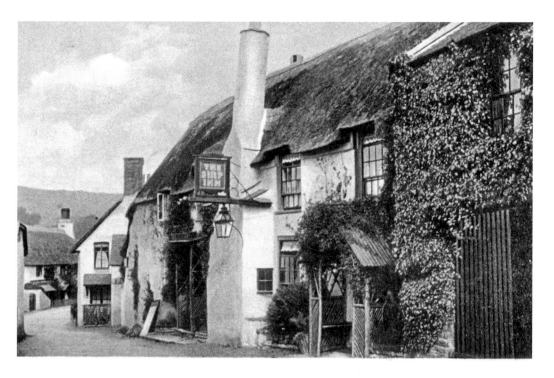

Porlock, The Ship Inn, c. 1905
It is not just the landscape around Porlock that is attractive, there are some fine buildings in the village as well. Here is one of them – the seventeenth-century Ship Inn at the western end of the village where the road starts to rise on its twisting course up Porlock Hill.

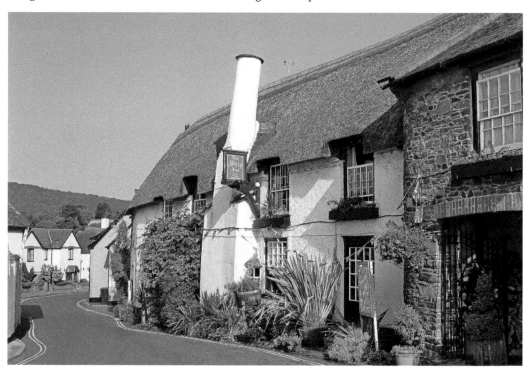

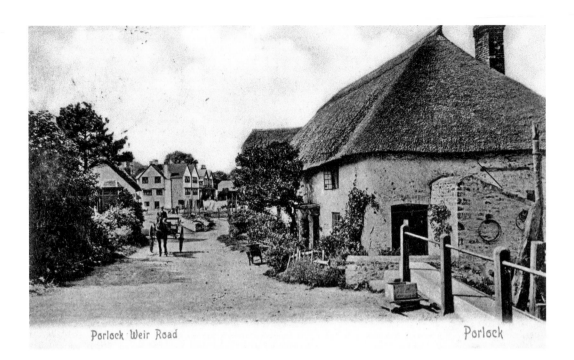

Porlock Weir Road

Porlock

Porlock Weir, View Towards the Harbour, *c.* 1905

Porlock itself lies about half a mile inland, and since the Middle Ages its harbour has been at Porlock Weir, a mile and a half to the west. This view looks along almost the whole length of this little settlement; the cottage on the right is the first one on that side of the road as you approach from Porlock, and the large building in the background is the Anchor Hotel down by the harbour.

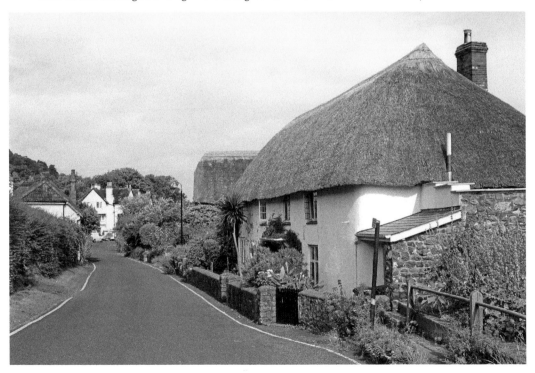

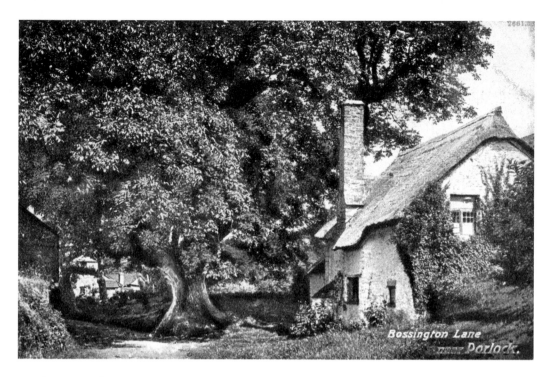

Bossington, Walnut Tree, *c.* 1900

A mile or so north-east of Porlock and beneath the hill that bears its name, we find the little village of Bossington. There are still a number of walnut trees around the village, but the old picture shows by far the best known. It was around three hundred years old when the picture was taken, and it had to be felled about half a century later.

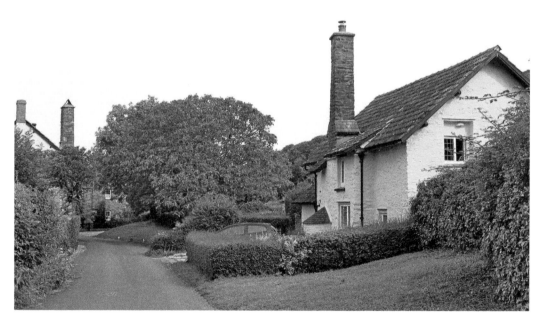

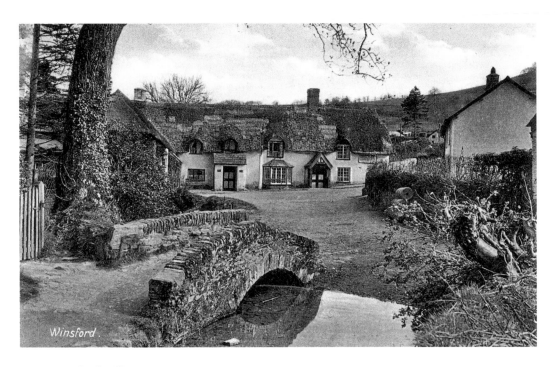

Winsford.

Winsford, Village Scene, c. 1920

Winsford lies roughly ten miles south of Porlock, deep in the Exmoor National Park. The River Exe skirts around the village on its way towards Devon, and here we see a medieval packhorse bridge that crosses one of its tributaries, Winn Brook. The sixteenth-century Royal Oak Inn is in the background.

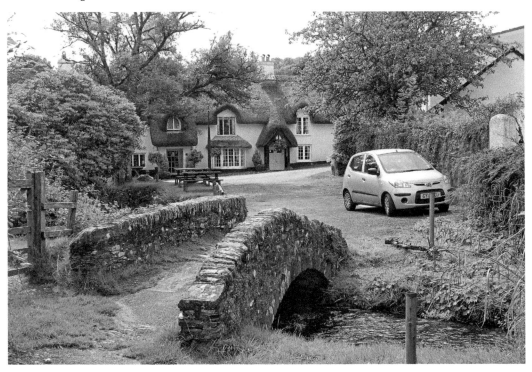

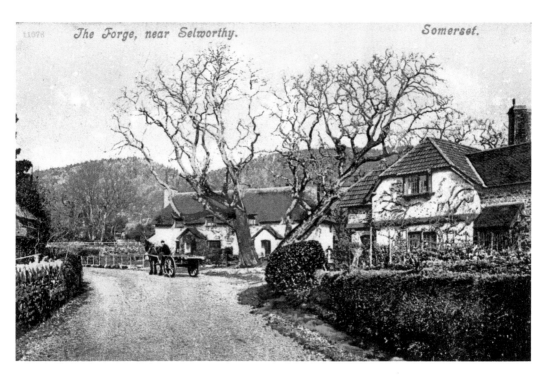

Selworthy, Buddle Hill, *c.* 1905

We head back north towards the coast. The picturesque village of Selworthy lies between Porlock and Minehead and is owned by the National Trust. Here we see the little hamlet of Buddle Hill, half a mile to the south-west. It was on the main coast road, but this has now been diverted around it. The stream in the foreground flows down between the two cottages.

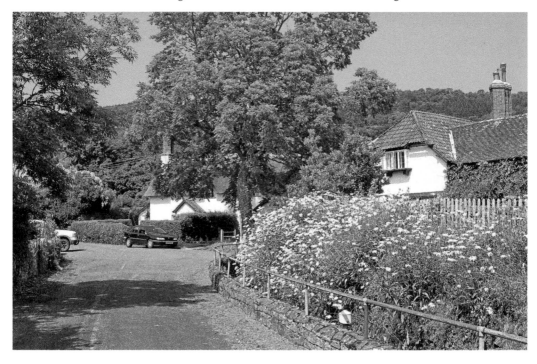

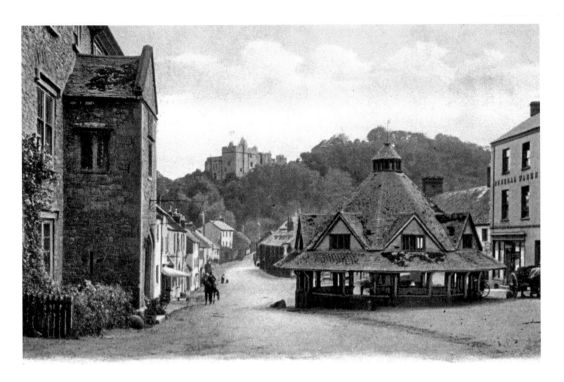

Dunster, Castle and Street, *c.* 1900

A couple of miles east of Minehead is the picturesque village of Dunster. Here we see an iconic view of the main street and the medieval castle beyond. The latter belonged to the Luttrell family from 1376, and around 1600 one of their number built the Yarn Market, which is the octagonal structure in the market place that we see on the right. To extend the family connection, the 500-year-old Luttrell Arms is on the left.

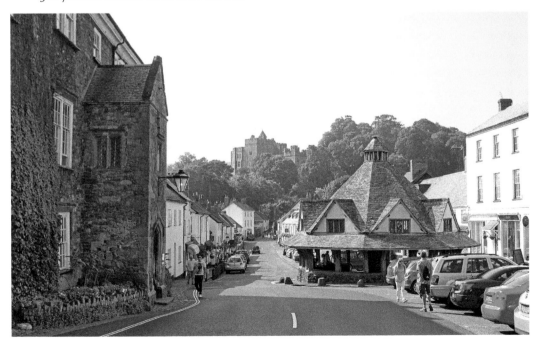

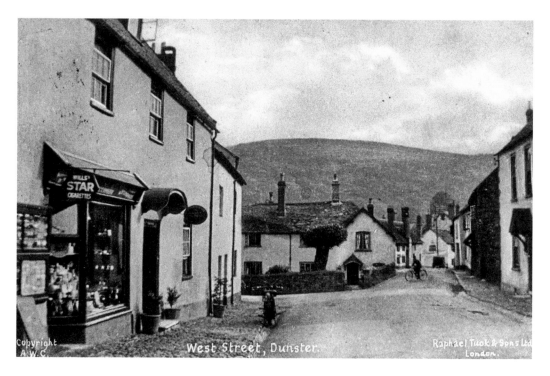

Dunster, West Street, c. 1930

Heading in the direction that we were looking in the previous photograph, we find ourselves in West Street. Mill Lane comes in just past the properties on the left, and beyond that is the bridge that crosses the Mill Stream.

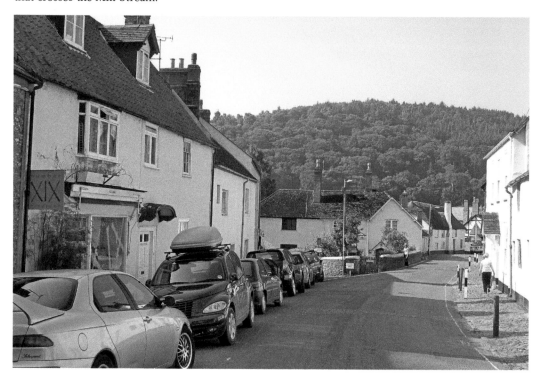

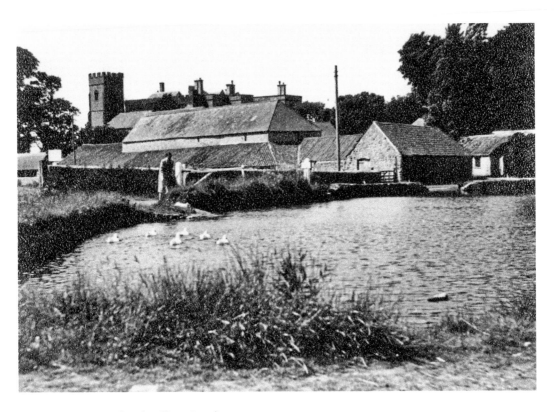

East Quantoxhead, Village Pond, *c.* 1930

Further east past Watchet lie the villages of West and East Quantoxhead. As their names suggest, they lie just below the northern end of the Quantock Hills, and East Quantoxhead is just a few hundred yards from the sea. When I visited the village pond had been drained for repairs, or rather 'revamping' as one of those involved put it!

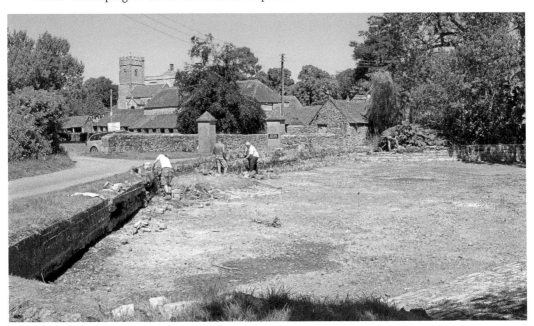

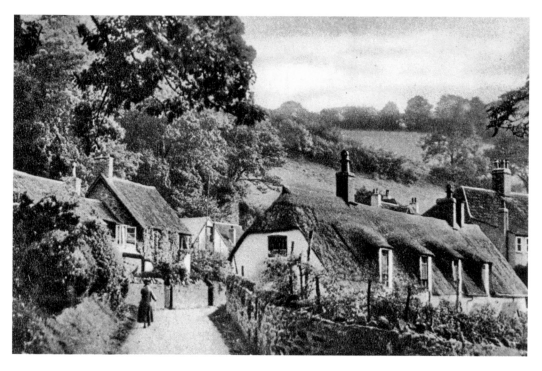

Holford, Looking Towards Holford Combe, *c.* 1930
Next we swing around the head of the Quantocks to a village that lies under their eastern slopes. The centre of Holford is by the coast road, but it also extends into a couple of combes that cut into the hills. Holford Combe is one of these.

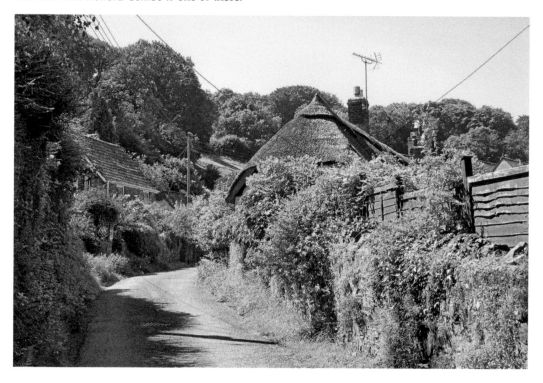

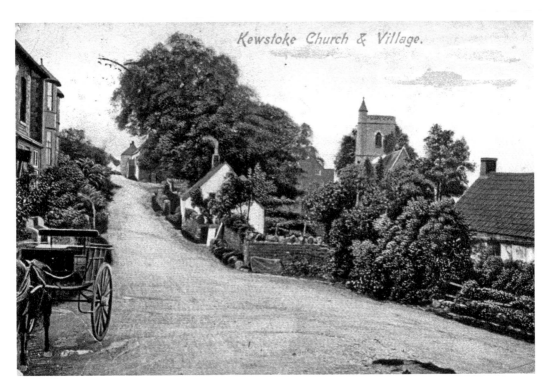

Kewstoke, Church and Village, *c.* 1900

Kewstoke lies on the other side of Worlebury Hill from Weston-super-Mare, overlooking Sandy Bay. The steep north face of that hill has prevented Weston-super-Mare's suburbs from enveloping the village. This view has not changed a great deal over the past century, although the cottage in the middle has gone.

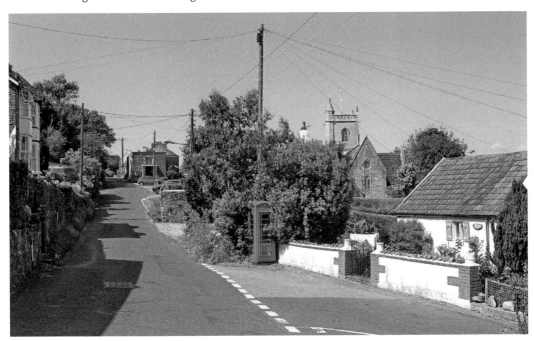

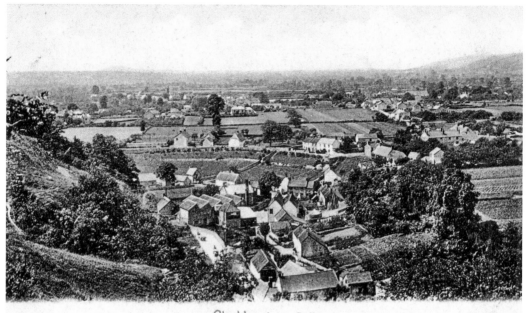

Cheddar from Cliffs

Cheddar, View from Cliffs, c. 1905

Cheddar lies about ten miles inland on the south side of the Mendip Hills. These views were taken from the hill above Cheddar Gorge, and look west towards the Bristol Channel with the Mendips on the right and the isolated hill of Brent Knoll just visible in the distance on the left. My photograph includes Cheddar Reservoir, constructed in the 1930s and filled by the Cheddar Yeo river that flows from Cheddar Gorge. It also shows how much Cheddar has expanded in the past century.

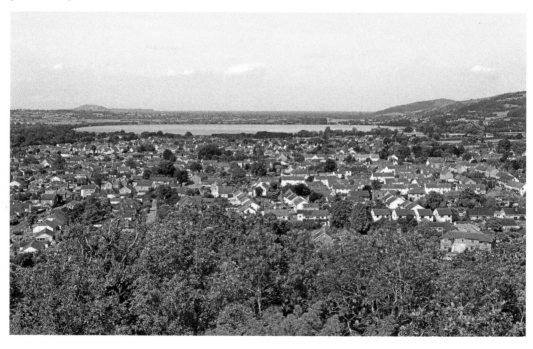

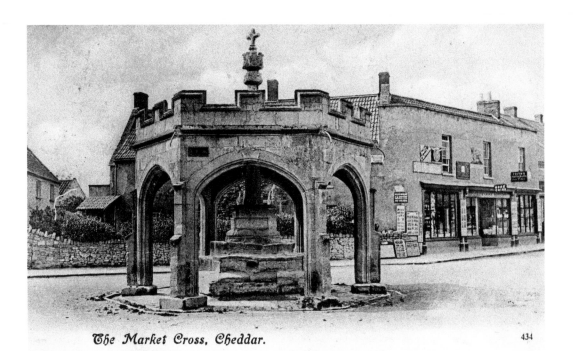

The Market Cross, Cheddar. 434

Cheddar, Market Cross, *c.* 1910

Like Glastonbury, Cheddar has a Market Cross at a central road junction. The cross and its base date from the fifteenth century, but the shelter around it was added later. I took my photograph while the Cross was undergoing a series of repairs following a road accident.

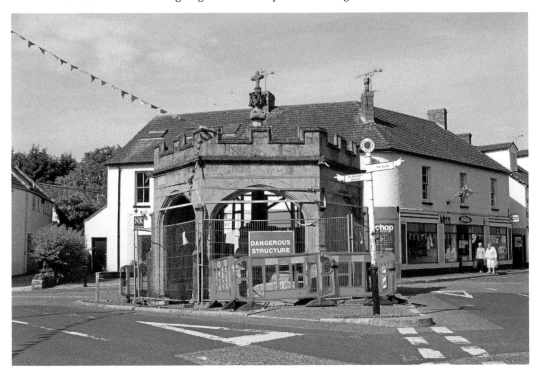

Cheddar, Cottage in Cheddar Gorge, *c.* 1925
The village extends into the lower reaches of Cheddar Gorge, the largest and best-known of the gorges that cut into the limestone of the Mendips. Hillside Cottage now houses a tearoom, and in the foreground is a small lake that is part of the Cheddar Yeo. There is less scrub on the hill beyond today than when the old photograph was taken; elsewhere in the Gorge the opposite is true after grazing by sheep ceased in the 1920s.

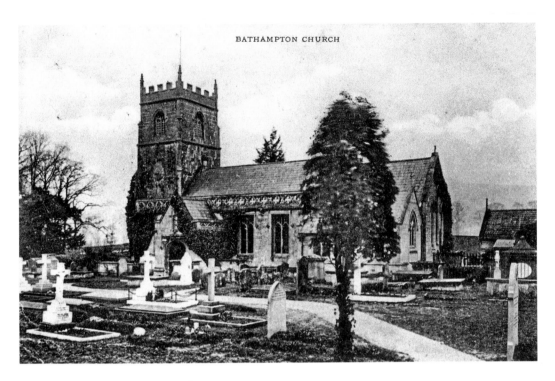

Bathampton, Parish Church

Bathampton is a couple of miles north-east of Bath, in a loop of the River Avon. Much of the parish church of St Nicholas was rebuilt in the nineteenth century, and my view also shows the extension on the east side of the building that was opened in 1993. The section with the gable is called the Miller Room.

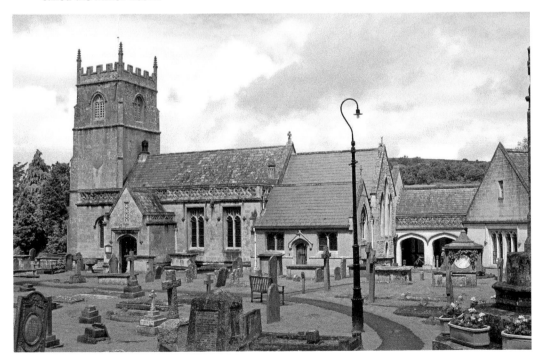

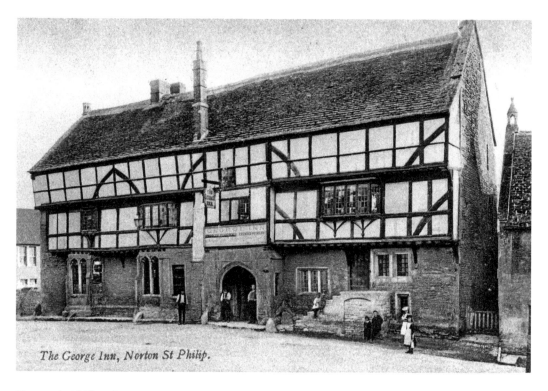

The George Inn, Norton St Philip.

Norton St Philip, The George Inn, *c.* 1905

Norton St Philip is six miles south-east of Bath, not far from the Wiltshire border. The establishment we see here dates from around the fifteenth century and has been described as 'one of the most remarkable medieval inns in England'. Barring the odd chimney, it seems to have changed very little over the past century.

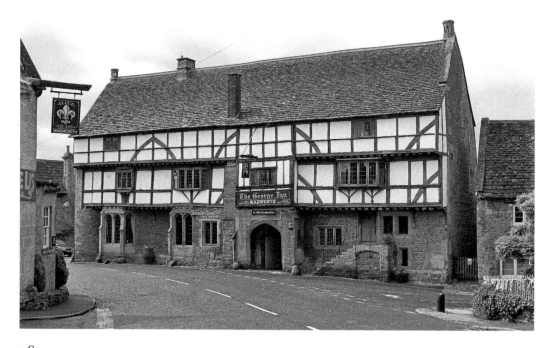

Life in Somerset

The Park, Taunton.

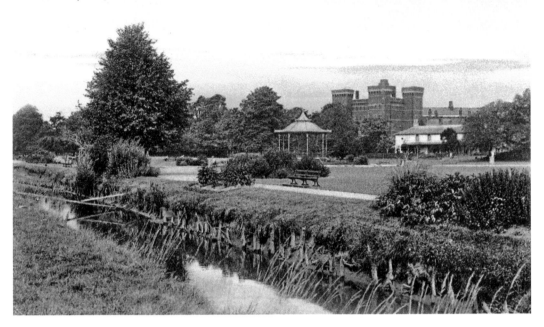

Taunton, Vivary Park, *c.* 1900

In the later nineteenth century, parks were recognised as important areas for leisure in the growing towns and also became signs of urban prosperity. We will look at some examples here. Vivary Park was sold to the town of Taunton in 1894 by the Kingland family and opened as a public park the following year. It had effectively been a private park for some decades previously, which explains why the trees in the old photograph are already mature.

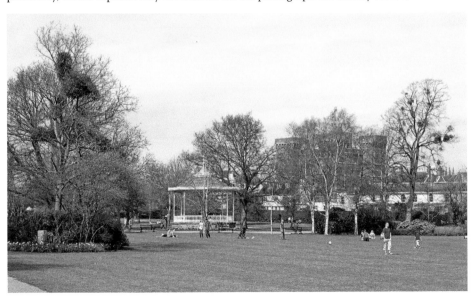

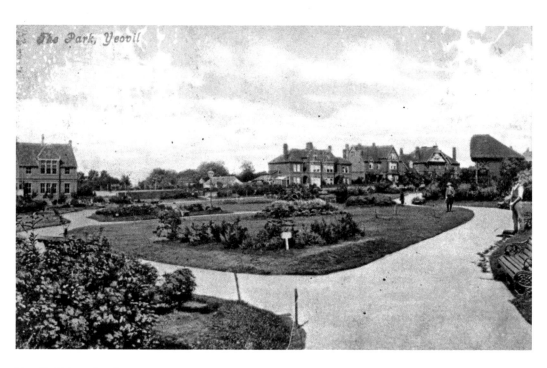

The Park, Yeovil

Yeovil, Sidney Gardens, *c.* 1905

Sidney Gardens were opened in 1898 and were named after Yeovil's then mayor, Alderman Sidney Watts, who donated them to the town. The old photograph was taken only a few years later, and the planting all looks new. The Gardens lie in the area known as The Park, where new houses were being built over several decades in the late nineteenth and early twentieth centuries – the gap between the houses in the old photograph gives an idea of this piecemeal development.

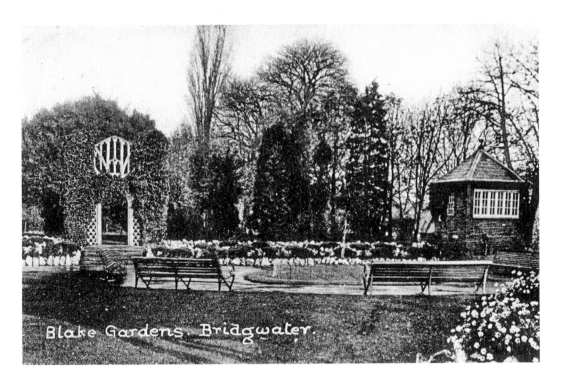

Blake Gardens. Bridgwater.

Bridgwater, Blake Gardens, c. 1910

Blake Gardens lie on the south-east of Bridgwater town centre beside the River Parrett. They were opened in 1902 to celebrate the Coronation of Edward VII, and were named in honour of Admiral Blake, whose statue we saw before. The view here has changed much more than in the two previous parks – only the steps on the left in both pictures convinced me that I had found the right location.

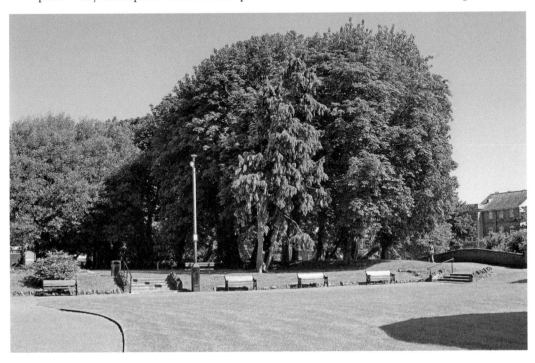

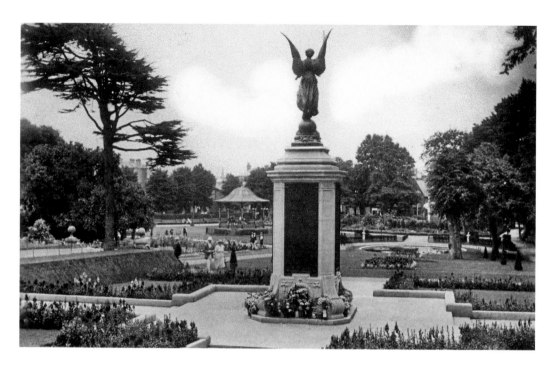

Weston-super-Mare, War Memorial in Grove Park, *c. 1930*

Grove Park has a similar origin to the three previous cases, being bought by the town from the local lord of the manor in 1889. After the First World War the Memorial we see here was erected to the men of the Weston-super-Mare area who died in that conflict. Today there is also another memorial behind the spot from which these pictures were taken, which honours the local service personnel and civilians who died in the Second World War.

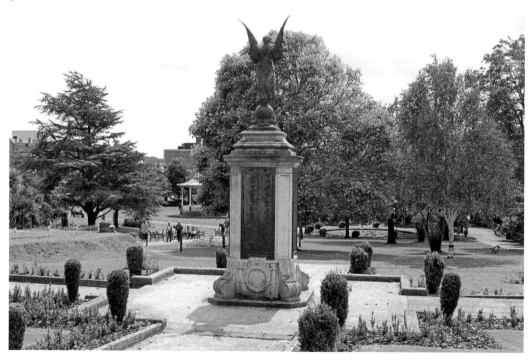

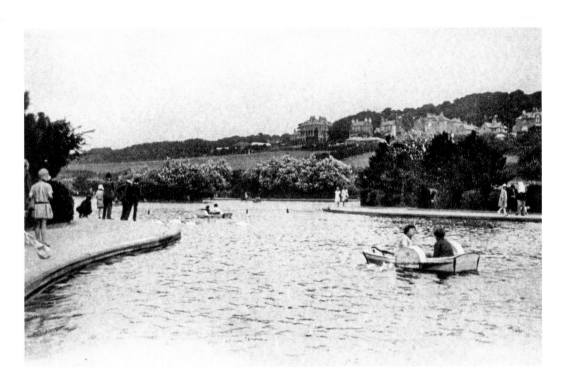

Portishead, Marine Lake, *c.* 1925

Now for a coastal example. Marine Lake is an artificial construction just inland from Woodhill Bay on the north-west side of Portishead (it is visible in the previous view of that town). Its excavation in 1910 provided work for unemployed men from Bristol, and the park called Lake Grounds was formed around it.

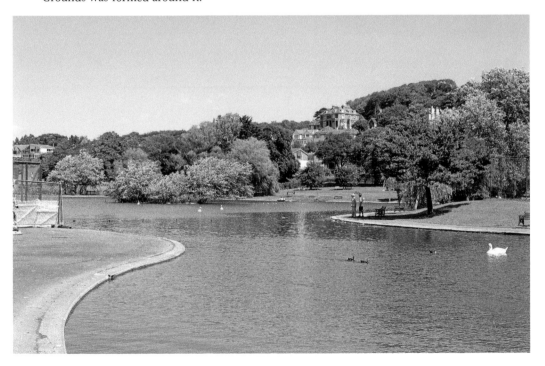

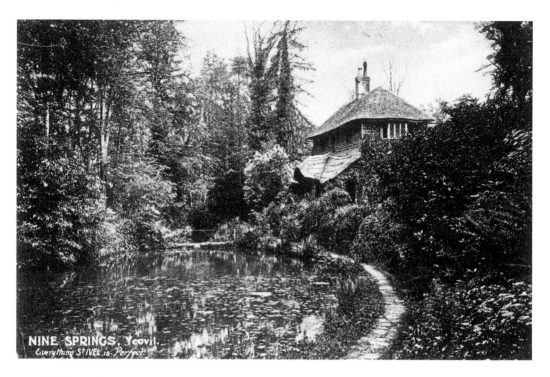

Yeovil, Nine Springs c. 1900

Here is a rather different case. Nine Springs lies on the south side of Yeovil. In Victorian times the area was a privately-owned pleasure garden, while today it belongs to the local district council and has been incorporated into Yeovil Country Park. Ninesprings Cottage that we see here was the tearoom for the pleasure gardens, and though it was demolished in the 1960s visitors can still find the terrace on which it was built.

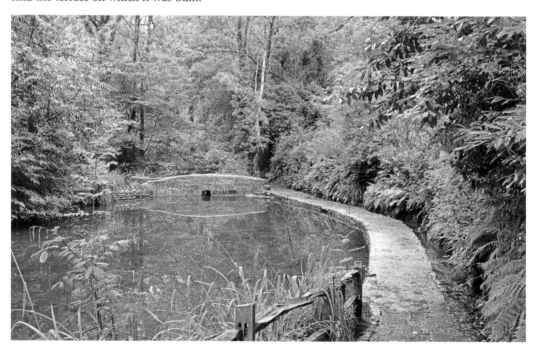

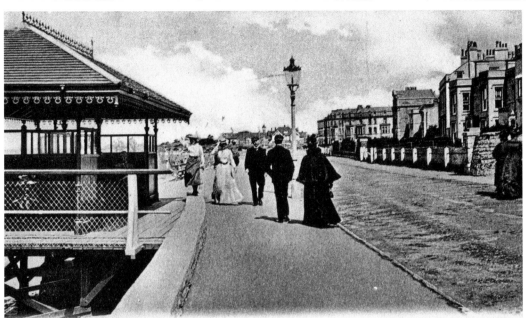

Burnham. *Shelter and Promenade.*

Burnham-on-Sea, Promenade, c. 1905

Seaside holidays have been an important element in people's lives, and of the Somerset economy, for the past two hundred years, and I will use three examples all from Burnham-on-Sea. As the name suggests, promenades were laid out so that people could enjoy walks with good views in the healthy sea air. These pictures look towards the junction with Sea View Road, and the old one pre-dates the construction of the concrete sea wall in 1911.

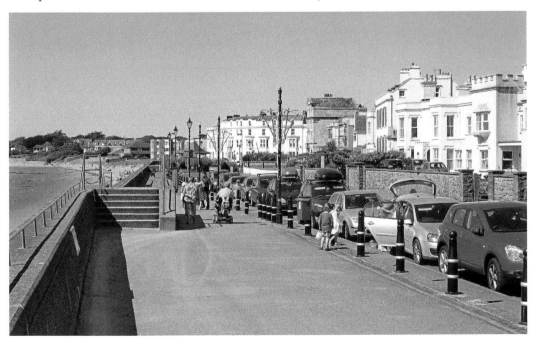

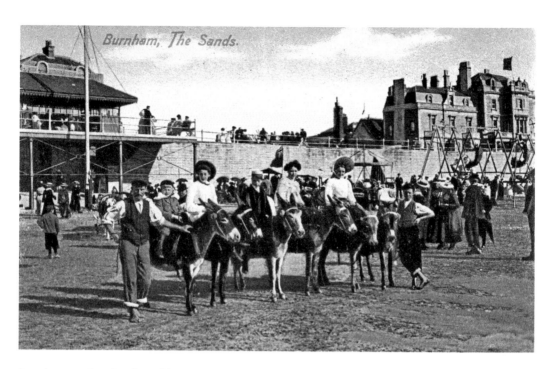

Burnham-on-Sea, Donkey Rides, c. 1910

Donkey rides for children, and the occasional adult, have been a feature of trips to the seaside since Victorian times. The viewpoint here is south of the photographs on the previous page, with the Reeds Arms Hotel on the right. This part of the beach is still used for donkey rides – their tracks in the sand are visible in the foreground of my photograph.

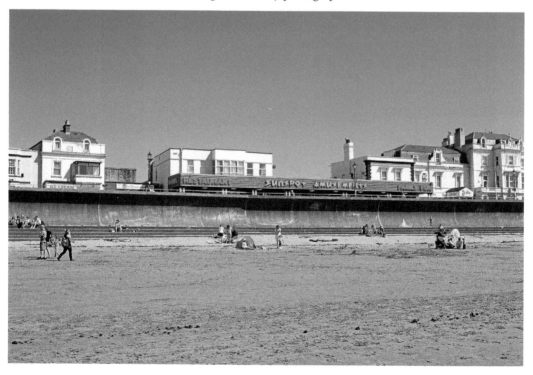

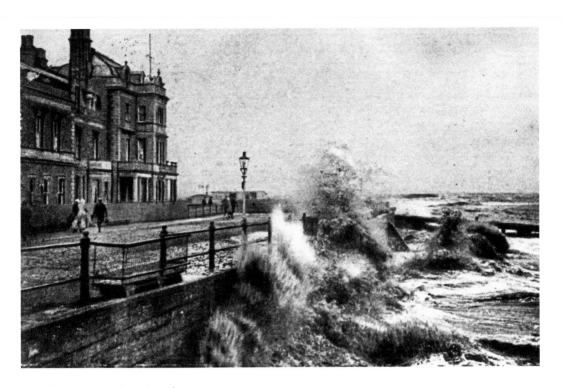

Burnham-on-Sea, Rough Sea, *c.* 1915

Despite how we often remember childhood holidays, the weather was not always perfect. Here we have moved up to the promenade in the middle of the last shot, and have the Reeds Arms Hotel on the corner of Pier Street on the left, and the old stone pier on the right.

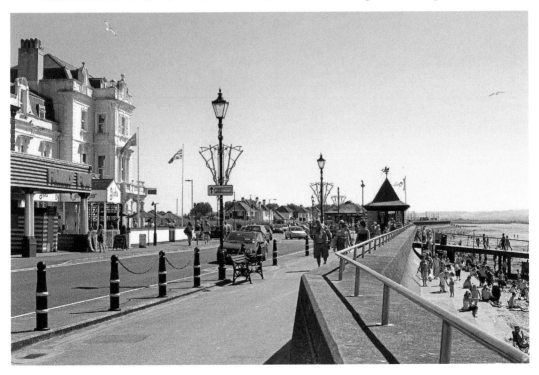

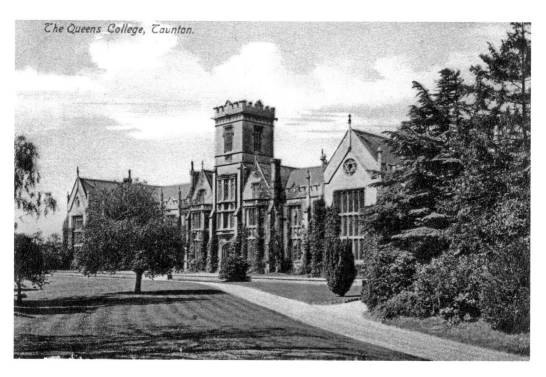

The Queens College, Taunton.

Taunton, Queens College, c. 1905

All the locations in this chapter so far have been linked to leisure, so I need to include something about another essential part of life – education. Queens College lies on Trull Road in the south-west suburbs of Taunton. It is a Methodist school that was formed in 1843, although the main building that we see here was not built until 1874. It was constructed in the Tudor Gothic architectural style.

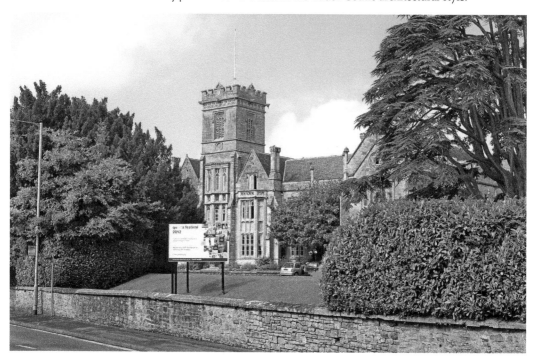

Historic Features

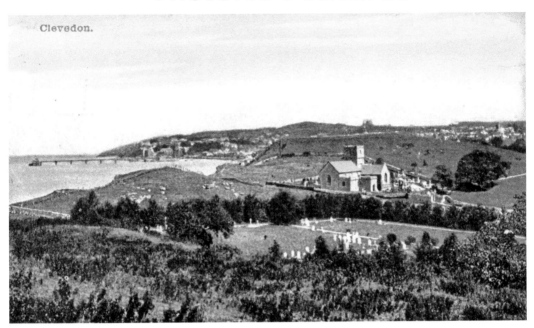

Clevedon.

Clevedon, View from Wain's Hill

In this final chapter, we will have a look around some of Somerset's historic monuments and buildings. First is the oldest of our subjects, Wain's Hill, an Iron Age hill fort on a headland on the south-west side of Clevedon. From the hill fort, we look across to Clevedon's twelfth-century parish church, and beyond it Church Hill that separates it from the town centre. There is a graveyard extension in front of the church – you will have to take my word because of the trees, but this has now filled up.

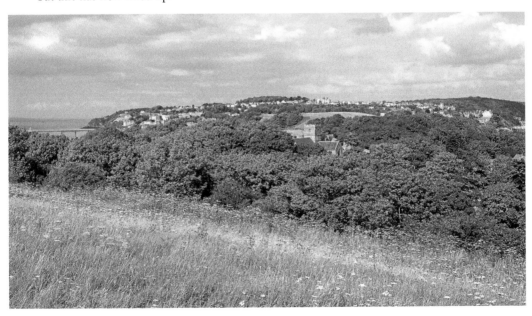

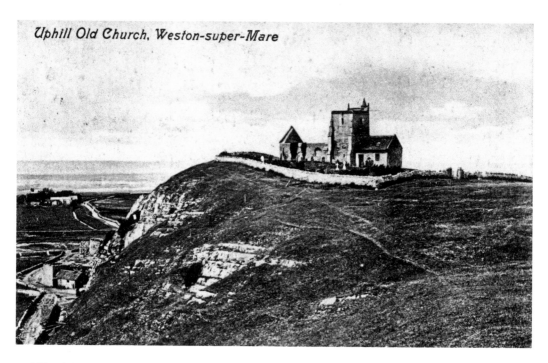

Uphill Old Church, Weston-super-Mare

Uphill, Old Church, *c.* 1905

Uphill is a village at the southern end of Weston Bay that has not yet been engulfed by Weston-super-Mare. The village presumably got its name from the hill on which the now-ruined Norman church stands. These photographs hint at the superb panoramic views from this hill. To the north is the sweep of Weston Bay and Wortlebury Hill, the northern Somerset Levels stretch inland with Brent Knoll and the Quantocks beyond, and across the Bristol Channel are Cardiff and the mountains of South Wales.

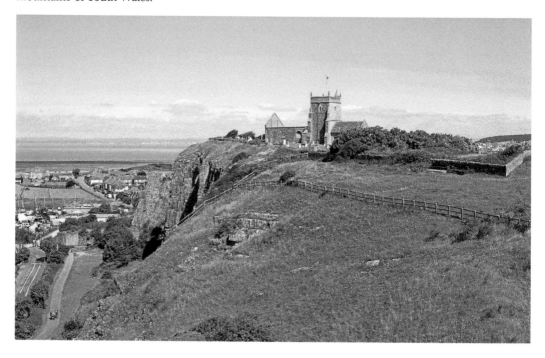

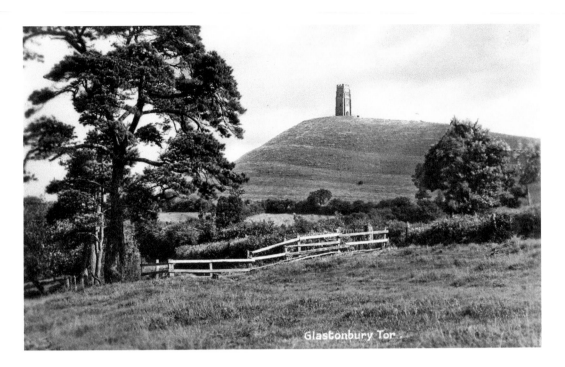

Glastonbury Tor

Glastonbury, The Tor, *c.* 1925

Glastonbury's most recognisable feature has many associations with history and myth. The Tor is a natural hill with panoramic views across the Somerset Levels, but cultivation terraces were cut into its sides in the Middle Ages. On top is a tower, all that remains of a thirteenth-century church. You might just be able to make out figures on the hilltop in my photograph – evidence of the Tor's increased popularity with visitors.

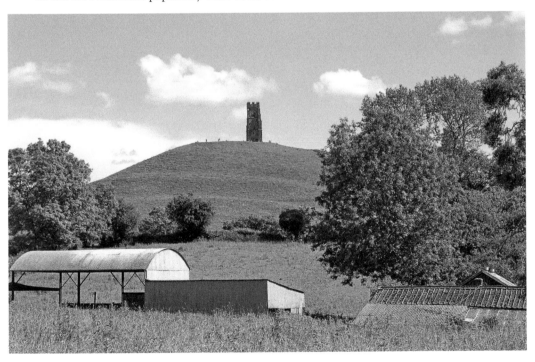

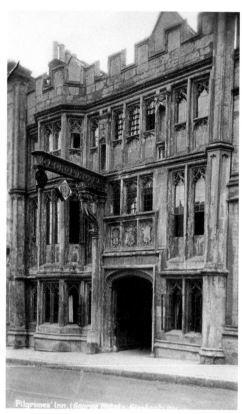

Pilgrimes' Inn (George Hotel

Glastonbury, The George Hotel, *c.* 1925
In the town itself we find this building in
the Market Square. The George Hotel, or the
Pilgrims' Inn as it was originally called, is a
rare survival of a medieval inn. It was built
in the fifteenth century to provide lodgings
and sustenance for pilgrims who came to
Glastonbury Abbey.

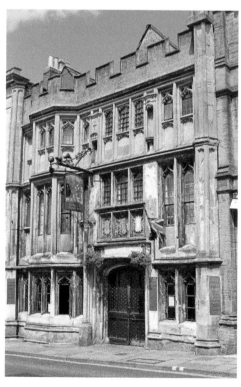

Glastonbury, The Tribunal, *c.* 1905

This is just a few properties away from the George Hotel in Glastonbury's High Street. Again it dates from the fifteenth century, although the frontage we see here was added a century later. As the name suggests, The Tribunal was originally the abbey's courthouse, and it was used by the infamous Judge Jeffreys for trials of the Monmouth rebels in the 1680s. It now houses the town's Tourist Information Centre and museum.

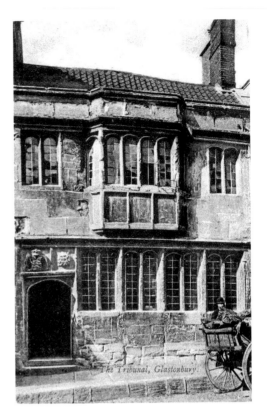

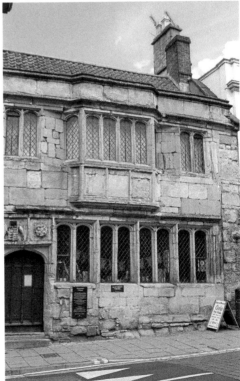

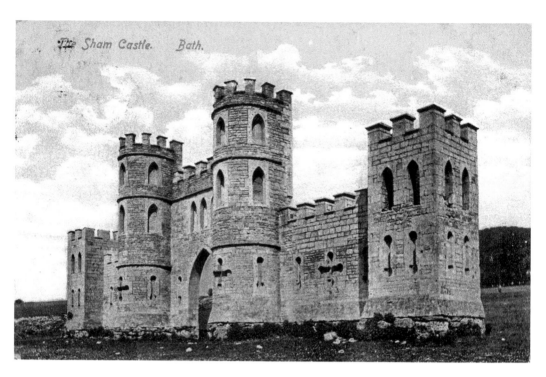

The Sham Castle. Bath.

Bath, Sham Castle, *c.* 1900
This folly is on the side of Bathampton Down to the east of Bath, not far from the University. It was built in 1752 for Ralph Allen, the local mayor and MP, who had made much money from reforming the Postal Service, some of which he invested in quarries on this hill. The idea was that it could be seen from his townhouse in Bath, but presumably he was also showing off to the rest of the townspeople.

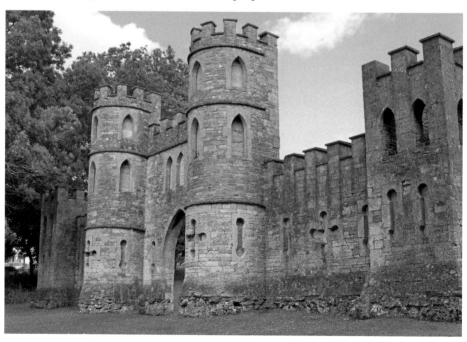

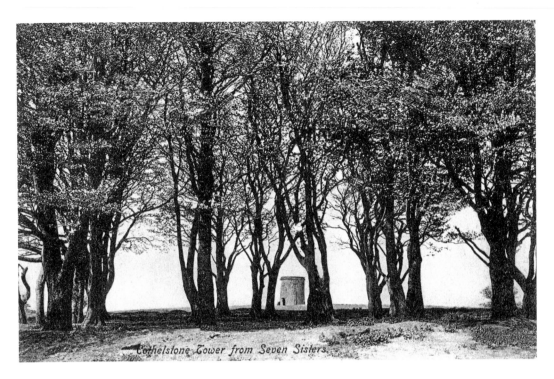

Cothelstone Tower from Seven Sisters.

Cothelstone Hill, Cothelstone Tower from Seven Sisters
Finally we are on the Quantocks, some five miles north of Taunton. Cothelstone Tower was built about two hundred years ago. It was another folly, and from it panoramic views could be enjoyed. It is barely visible today – just a few stones on a mound. The beech trees called the Seven Sisters have also suffered; many are now replacements for ones lost in storms. I am very grateful to some of the Exmoor ponies that graze the hill for posing for my photograph.

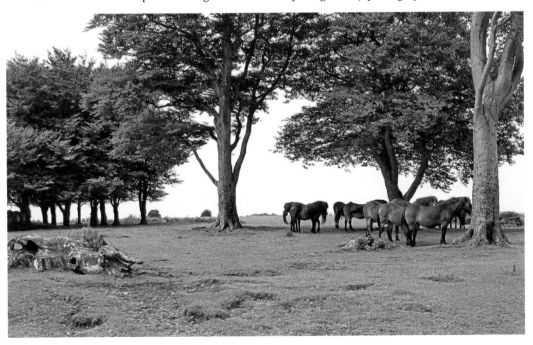

ALSO AVAILABLE FROM BRADWELL BOOKS

Wiltshire Through Time
Steve Wallis

This fascinating selection of photographs traces some of the many ways in which Wiltshire has changed and developed over the last century.

978 1 4456 0721 4
96 pages, full colour